WOLVERHAMPTON IN 50 BUILDINGS

STEVE BOWER

AMBERLEY

To my parents and my brother, and to Marion, Jacob and Bruno

First published 2022

Amberley Publishing, The Hill, Stroud
Gloucestershire GL5 4EP

www.amberley-books.com

Copyright © Steve Bower, 2022

The right of Steve Bower to be identified as the Author of this work has been asserted in accordance with the Copyrights, Designs and Patents Act 1988.

Map contains Ordnance Survey data © Crown copyright and database right [2022]

British Library Cataloguing in Publication Data.
A catalogue record for this book is available from the British Library.

ISBN 978 1 3981 0691 8 (print)
ISBN 978 1 3981 0692 5 (ebook)

Typesetting by SJmagic DESIGN SERVICES, India.
Printed in Great Britain.

Contents

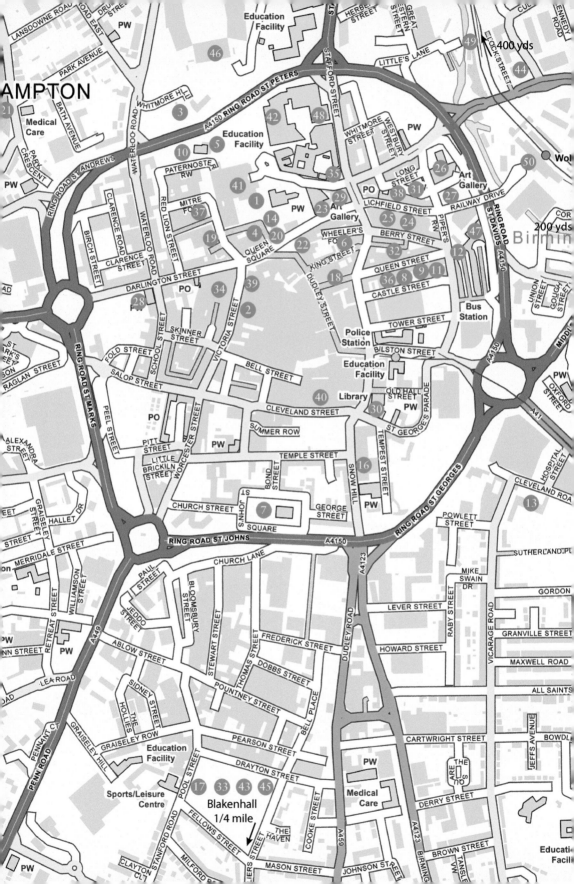

Key

Introduction

My family moved to Birmingham in 1966 for my father's work in Ettingshall, on the edge of Wolverhampton. The town intrigued me. I visited with my brother, parking on the roof of the Wulfrun Centre. We found St John's Church and the remaining Georgian streets around it. The Mander Centre impressed me as it had the Civic Trust carefully slotted into place at the end of the original Victoria Arcade from Dudley Street. However, much of the town centre was still dominated by traffic then. Buildings were black with grime.

I went back to Wolverhampton as a tourist in October 2019 for the first time since 1970. The town, now city, was transformed. The walk into town from the railway station is now straight across the glass-sheltered and painted-glass decorated footbridge over the ring road. Traffic no longer uses the city centre. You walk up Lichfield Street, past the Grand Theatre and the old post office building, with Princes Square and the Royal London Buildings marking the start of the city centre. Just beyond are Wolverhampton Art Gallery and the gardens below St Peter's Church. The centre really works, with Dudley Street bustling and the Wulfrun and Mander Centres having matured into attractive places to shop or pause from shopping.

Wolverhampton was an important but tiny market town with a grand church until the seventeenth century. Late eighteenth-century canals and Black Country minerals – iron, limestone and coal – fired its growth from 7,454 people in 1750 to around 250,000 now. Early manufacturing entrepreneurs established metalworking industries, initially locks and decorated metalware and later major industries, cycle, car and railway manufacturing, boiler making and a wide range of metal trades; japanning was a particular local speciality.

Industrialists and town professionals subscribed to good causes: the first hospital – the six-bed dispensary in Queen Street – the Mechanics' institute, the Subscription Library. Leaders of industry became councillors and aldermen and promoted the first Free Library, new Town Hall buildings and the town's first parks. The council's 1875 Artisans' Dwelling and Improvement Act cleared slums and created Wolverhampton's city centre as it is now.

The 1930s Technical College has become the 20,000-plus-student University of Wolverhampton. Students keep the city centre active. The council safeguards Wolverhampton's heritage, preserving the best streets – King Street, George Street and Snow Hill, for example – and promoting the regeneration of Blakenhall. There are now new bus and rail stations and offices in its Interchange project. It is marketing underused sites in the south-west corner of the city.

This book is intended to guide people to the buildings that caught my attention when I visited. They are mainly within the centre, inside the ring roads. I have included a few highlights beyond, such as West Park, the Royal Hospital and some of the best modern buildings at Blakenhall and Springfield Campus. I don't include the country houses around Wolverhampton, which have already been described in all the guidebooks. I have skipped worthwhile buildings in the suburbs. The Royal School and Wolverhampton Grammar School, for example, are good buildings but difficult to explore. Please enjoy this guide and enjoy the city. It's an unrecognised gem.

The 50 Buildings

1. St Peter's Collegiate Church, Lichfield Street (1200s onwards)

There were early religious foundations here, with a royal chapel with a college of priests in place by the time of the Norman Conquest.[1] The earliest surviving building is the thirteenth-century crossing beneath the tower. The south transept is substantially fourteenth century, remodelled when the nave was built in the late fifteenth century. The upper part of the tower was rebuilt and the north transept added. The church was virtually complete by the end of the century.

St Peter's Collegiate Church at the heart of the city.

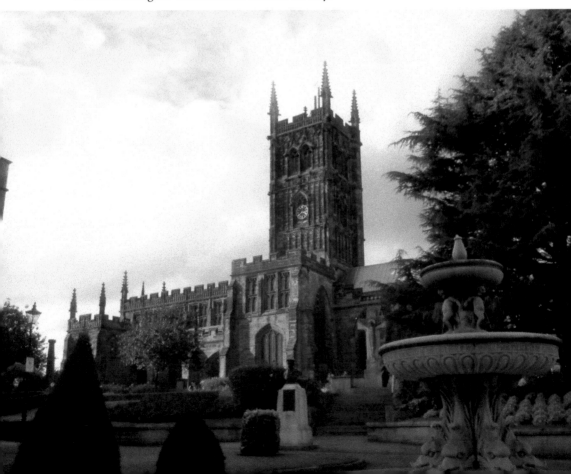

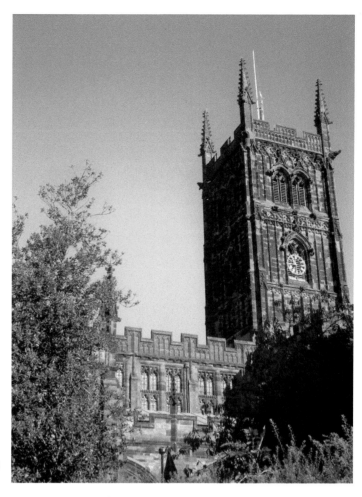

Fine sandstone
carving at St Peter's
Church.

The Victorian chancel at the east end of the church is in a Decorated style with
four bays and a seven-sided apse. It was built in 1867 by Ewen Christian at the
end of the restoration of the whole church from 1852 onwards. Much external
stonework was renewed. Dormer windows behind the battlements brought new
light into the aisles and nave.

From outside you can see the lovely carved stone and intricate details. Inside,
the church has red sandstone walls and arches, strikingly offset by the chancel and
nave decorated ceilings from 1968–70.

The pulpit is an impressive piece of stone carving, panelled and with an
extraordinary staring lion. Built into the nave, it is thought to date from the
late fifteenth century. There are fine monuments attributed to Robert Royley of
Burton on Trent in the north transept: the Leveson family memorial and the Lane
family monument. Vice Admiral Sir Richard Leveson, involved in the defeat of the
Spanish Armada in 1588, is commemorated in the south transept. His statue is by
Hubert Le Sueur, court sculptor to Charles I.

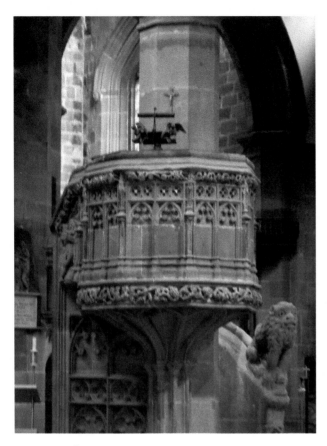

The fifteenth-century pulpit and its guarding lion. (Photo included with thanks to David Wright, Team Rector, parish of Central Wolverhampton)

Colonel John Lane (d. 1667) has his memorial, attributed to Jasper Latham, in the north transept. In 1651, Lane helped Charles II to escape after his defeat at the Battle of Worcester. The carved crown and the oak tree on its base commemorate his assistance.

There is also good stained glass (including German and Flemish glass) in the side windows of the chancel, saved from St Mary's Church, Stafford Street, when it closed in 1948.

2. Lindy Lou Café, No. 19 Victoria Street (1590s)

This is one of the few old buildings in Wolverhampton. It is not as old as the board above the front windows claims – AD 1300 – but is certainly fifteenth or sixteenth century. It has been suggested that the style of construction indicates it was built in the 1590s – perhaps after the April 1590 fire that destroyed houses in this area.[2]

The oldest record of the building discovered so far is a 1609 terrier (land holdings record) of Sir Walter Leveson's Wolverhampton estates. Nicholas Worthington occupied one messuage and common inn called 'the Hand' in

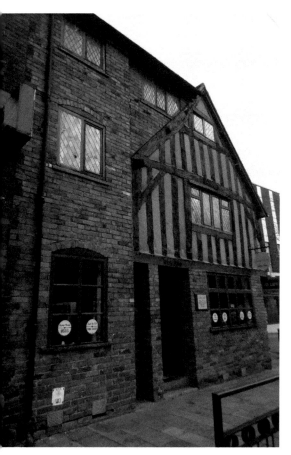

Above left: Lindy Lou's coffee shop in Victoria Street.

Above right: '1300 AD' on Lindy Lou's beam – around 300 years too early.

Tunwall Street (an early name for Victoria Street) alongside St John's Lane at an annual lease of £2 17s 4d.

The main structure of the Hand inn has barely been altered. There are stone foundation walls supporting a post and truss construction. The important west gable frontage to Victoria Street has a bold arrangement of close vertical posts. The subsidiary St John's Street side wall has square panels. Infilling is with herringbone or horizontal brick layers.

The property remained an inn throughout the 1600s, but had been subdivided into small tenements by the eighteenth century. In 1818, all or part was used as a bakery by Edward Farmer, succeeded in 1827 by Mary Farmer, baker and flour dealer. The bakery business continued through the 1800s. The name, Lindy Lou, comes from a pram and toyshop here in more recent times.

The building was restored in 1979–81, with details celebrated on the plaque fixed on the St John Street wall. It continued to have a chequered history of

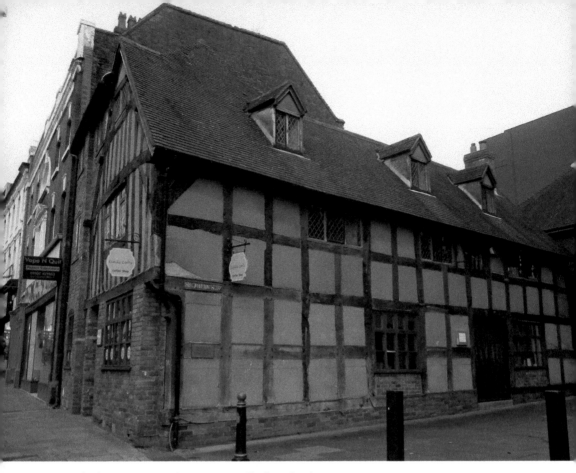

The less ornate St John's Street wall of Lindy Lou.

occupation as a Welfare Advice Centre, an Employment Agency, from 2004 it housed a gift shop on the ground floor, and it was later a book and collectables store. It was empty for more than a year before reopening as Lindy Lou's coffee shop in August 2017.

3. Molineux Hotel (c. 1720)

The Molineux Hotel is now quietly resting as Wolverhampton City Archives. The city council bought the hotel after years of dereliction and a major fire in 2003. It secured lottery funding to back restoration of the main building, demolish a Victorian extension and add a state-of-the-art new-build archive store. The Molineux Hotel now has a new grand staircase with delicate banisters, recreated oak panelling in the Oak Room, and fully restored plaster work in the ground-floor Rococo Room. New handmade glass in the windows brings the main building back to its original appearance.

The archive building, to the left of the hotel's front, viewed from the ring road, opened in March 2009. It keeps storage at 15–20 °C and relative humidity at

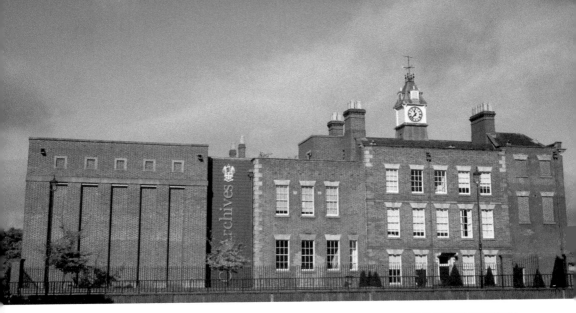

Above: Molineux Hotel and archive store from across the ring road.

Right: Molineux Hotel's recreated formal garden.

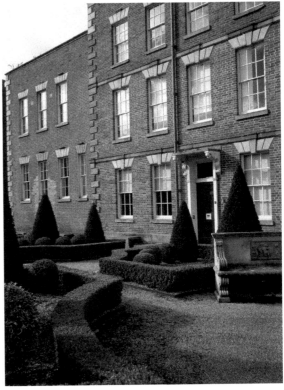

45–65 per cent. There is sensitive smoke detection and gas-based fire-suppression equipment. It's a substantial modern addition but respects the original historic frontage. Donald Insall Associates were the architects. The council's landscape architect, Nikki Hills, has recreated delightful eighteenth-century-styled landscape gardens in the spaces remaining at the front and rear of the house.

The oldest part of the house, the central five bays on either side of the entrance, was built in 1720. Its first recorded owner was John Rotton. He died in 1744 owing £700 to Benjamin Molineux, a wealthy local ironmaster and banker. Rotton's beneficiaries sold the house, including 8 acres of grounds, to the Molineux family to clear the debt. Succeeding Molineux family members stayed here until Charles Edward Molineux put the house and gardens up for sale in 1856.

The house became a hotel. Its gardens found new use as pleasure grounds and later as the first Molineux football ground. Local brewery William Butler & Co. bought the hotel in 1901. It prospered before the Second World War but was in decline by the 1950s, cut off from passing trade by the ring road in 1969, and closed in 1979 when its lease expired.

New owners' development proposals failed, and the building remained empty until its rescue by the city council.

4. Nos 43–44 Queen Square and Lych Gate Public House, Lich Gates (1726)

The front of this building facing Queen Square is a classic early Georgian façade in red brick, framed by stucco quoins at each side. Originally a house, by 1834 it was a George Cope's wine and spirit merchant. A century later, the shop was still trading as 'Cope's' in the 1950s.

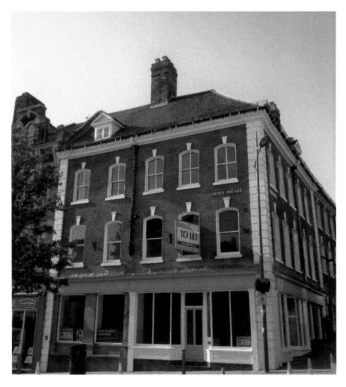

Nos 43–44 Queen Square.

The business originally extended into the second house along Lich Gates, now the Lych Gate Tavern. Its frontage has the same Georgian style as the front building – red brick and framed by quoins – but the windows are totally misaligned. This building was originally timber framed, and was awkwardly refaced when the front house was completey rebuilt. The wooden beams and the earlier arrangements are clear inside the pub where there are listed chamfered beams and jointed cruck trusses.

Even better, the part-timber-framed rear wall still exists and can be seen from Exchange Street. The top two storeys stand out above a brick base with the top-floor gable supported by brackets and jettied out. It's a rare survival, one of only two half-timbered façades remaining after many town fires from medieval Wolverhampton.

Queen Square was the commercial hub of Wolverhampton before the Wulfrun and Mander Centres were built. In the 1970s, Nos 43–44 Queen Square were occupied by ladies outfiters Joan's, later renamed Paige. The rear part was derelict and the council acquired it in the 1970s. Buildings in the yard on Exchange Street were cleared so that the historic half-timbered rear frontage was fully visible. After a period of council office use, the Lych Gates moved in and completed conversion to a real ale public house.

The council has continued its conservation goals and recently renovated this Queen Square frontage into its original Cope's Wine Lodge style using Wolverhampton surveyors Scott Franklin Associates.

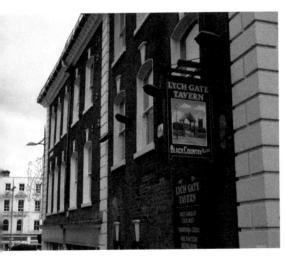

Above: Lych Gate Tavern, its wooden frame refronted in brick.

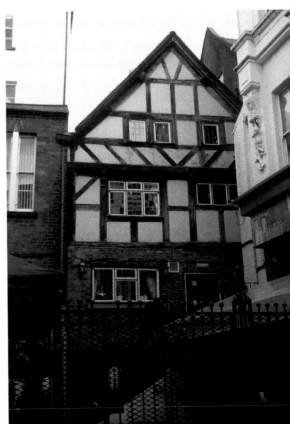

Right: The half-timbered back wall of Lych Gate Tavern.

5. Giffard House Presbytery and Chapel, No. 51 North Street (1728)

Major landowners the Giffards were ardent Roman Catholics and had been Royalists, helping the future Charles II escape to Boscobel after the Battle of Worcester in 1651. Architect Francis Smith (1672–1738) of Warwick completed a rebuild in 1724 of their Chillington Hall country seat at Brewood, 7.5 miles north-west of Wolverhampton. Smith followed on at Giffard House as architect and work must have started within a couple of years.

This house has always had a dual purpose. It was built with a deliberately cramped internal layout at the front. The house is only one room deep, with a study and dining room on the ground floor and bedrooms above. A spectacular staircase with spiral, fluted balusters zigzags upwards in the main hallway behind the entrance, leaving space for the chapel contained within the overall building. Originally a room in the house, it was enlarged, reputedly, in 1743.[3] In 1765, Italian workmen were employed to decorate and embellish it. The sanctuary of

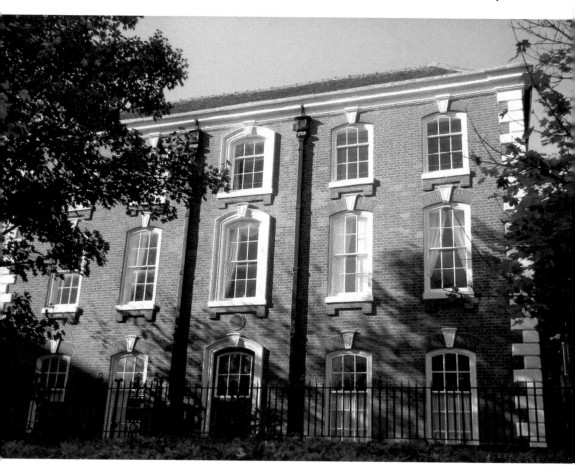

Giffard House, a simple Georgian frontage.

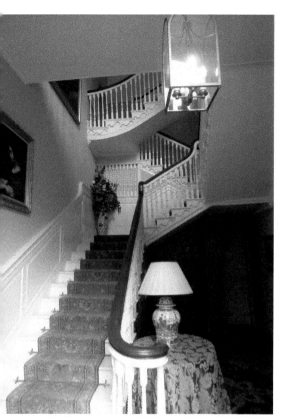

Above left: The elegant staircase at the front of Giffard House. (Photo included with thanks to Mgr Mark Crisp, Parish Priest, St Peter and St Paul's Church)

Above right: Plain brick 1920 extensions, hiding the Lady Chapel of St Peter and St Paul's Church inside.

St Peter and St Paul's Church with its dome lies entirely within the main house envelope, taking the space of the original Giffard House chapel.

When the house was built, Catholics could worship privately but not in public. Catholics from the town were welcome in the private chapel and no action was taken to prevent them coming.

Roman Catholic Bishop John Milner lived here from 1804 until his death in 1826. He was the Vicar Apostolic for the Midland District of the Church from 1803. Milner was a key figure in Catholic emancipation campaigns at the end of the sixteenth century and start of the seventeenth century. The Catholic Emancipation Act was passed in 1829, three years after Milner's death.

The chapel at Giffard House became the starting point for what is now St Peter and St Paul's Church (q.v.). The side elevation photo here shows how discreetly even in 1921 the northern chancel of the church could be fitted alongside the taller wall of the house.

6. King Street and Old Still Inn (1751 onwards)

This is a street of contrasts. The north side has a terrace of Georgian houses, beautifully restored in the 1980s after many years of semi-dereliction. Originally individual houses, these have progressively moved into commercial and shopping use as Wolverhampton town centre has grown.

King Street was originally Angel Street and appears to have been renamed around 1760. Uses were not always so respectable. Slightly older buildings, Nos 2 and 3 King Street, were once Madam Clarke's Beer House, a house of ill repute. They have improved and most recently were trading as the Grain Store, Gin Emporium and Kitchen.

King Street has been pedestrianised. Houses now provide offices for a collection of quiet town centre businesses, solicitors, etc., and a war games retailer.

Towards the east end, the Old Still Inn has a delightful late Victorian or Edwardian extravagant frontage. The 1886 1:500 Ordnance Survey map shows a single frontage public house, the Saracen's Head Inn. By 1896 the name had changed, two houses amalgamated and the owner was James Tate, a successful wine and spirit merchant. He and his wife Maria Tate, who is listed as licensee of the Old Still in 1896, were keen amateur musicians, an enthusiasm passed on to their daughter Margaret, one of their ten children. Born in Exchange Street in

Below left: The attractively restored Georgian terrace at King Street.

Below right: The Grain Store, once Madam Clarke's beerhouse.

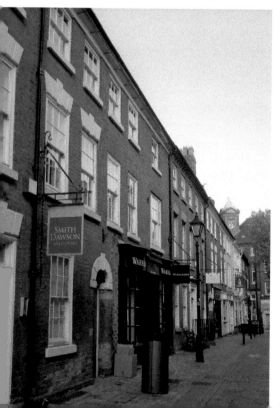
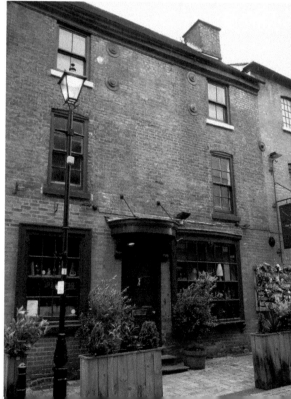

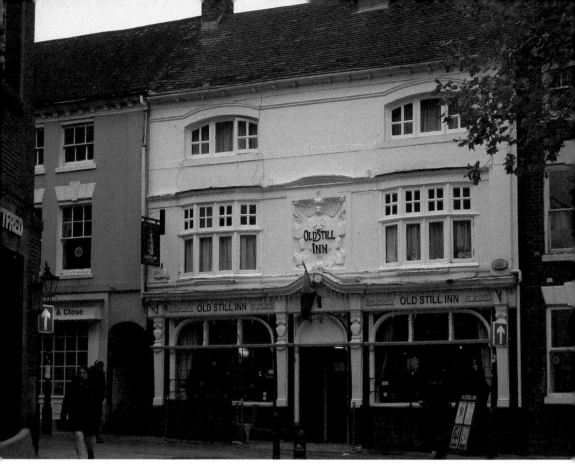

The exuberant Old Still Inn, King Street.

1888, she left England in her late teens to train in Paris as a singer. She studied with the composer Debussy to sing the title role in his opera *Melisande* at the Opera Comique in 1908. She became one of the great opera singers of the twentieth century, honoured as Dame Maggie Teyte.

In 2020, the Old Still continues its own tradition of entertainment, with regular musicians and karaoke events as well as keeping up with sport.

The south side has less to see. The 1933 former Staffordshire Building Society headquarters with its corner 'pagoda-like' clock tower marks the entry to King Street from Princess Street.[4] Architect G. A. Boswell included the stone eagles on the entrance face.[5] Nos 25/25a, two original houses, survive.

7. St John's-in-the-Square, St John's Square (1759)

St John's is one of four new churches for Wolverhampton needed in the early 1700s to supplement St Peter's.

Five local gentlemen owned and donated the site: Messrs Jesson, Sanders, Wightwick, Pershouse and Raby. The 4th Earl of Stamford and Warrington,

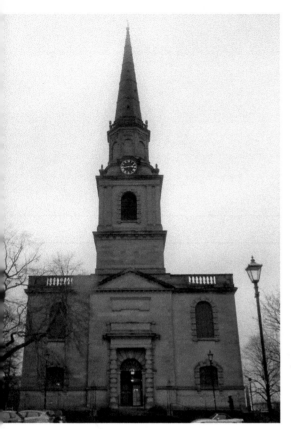 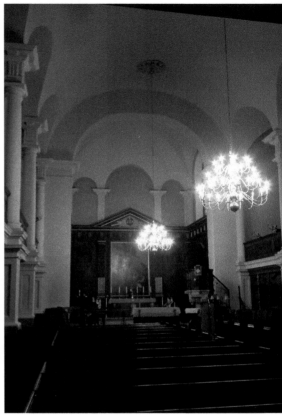

Above left: St John's Church, west frontage. Classicism at its best.

Above right: Inside St John's. (Photo included with thanks to the vicar, Revd Amanda Pike)

Lord Harry Grey, gave £1,000 to make up the building fund alongside private subscriptions. A 1755 private Act of Parliament gave consent to the church.[6] The likely architect was William Baker who, around 1753, completed James Gibbs' work on Sir John Astley's new hall at Patshull, just west of Wolverhampton.[7] St John follows the style of Gibbs' London Trafalgar Square church, St Martin's-in-the-Fields, built 1722–26.

St John's was brick built with a Perton freestone outer shell from the Wrottesley estate close to Patshull. This weathered poorly. The church was refaced from 1964 to 1979. Architect P. B. Chatwin used Hollington stone from Uttoxeter, which now seems to be wearing well. The building has fine Georgian details outside: the four main façades and the tower and spire. Inside, there is a beautiful, simple space, a nave with galleries on each side and classical pillars carrying an arched roof.

The church's organ by Renatus Harris originated in London at Temple Church, travelled through Christ Church Cathedral, Dublin, where it lasted until 1750, and, passing through Wolverhampton on its way back to London, it was sold to the newly built St John's for £500. Its beautiful case remains on the eastern gallery of the church

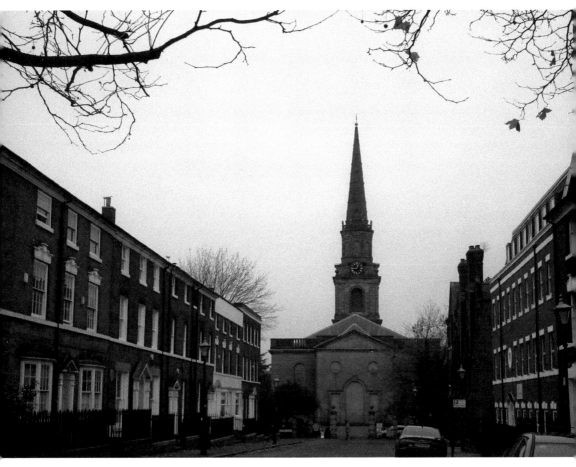

St John's and George Street, a well-conserved street scene.

and the organ is a good complement to the church's excellent acoustics. St John's has become a popular performing venue in addition to its religious function.

The church is at the centre of attractive preserved Georgian streets, George Street and Bond Street, named after the 1762 church organist William Bond. St John's Square once enclosed the church, but the decaying houses on its south side were sadly cleared for the ring road. In compensation, people driving past now have an open view of what must once have been a very secluded and little-seen church.

8. Subscription Library and Assembly Rooms, later County Court, No. 50 Queen Street (1815–29)

Moves to establish a subscription library in Wolverhampton started with a first meeting on New Year's Day in 1795. The library started up in the librarian Mr Tildesley's own house in King Street.

In 1806 the subscribers decided it was 'expedient to erect a building...' and by 1814 they had found this location – undeveloped land in Queen Street. They initially only built one storey, completing it two years later. The library rented three rooms: a reading room, a bookstore and a librarian's sitting room.

The elegant full building came into being in 1829 with a first-floor library and assembly rooms added, to designs by nationally successful architect Lewis Vulliamy. This building now had an Ionic colonnade, architrave and pediment. There was also a first-floor semicircular assembly room extension at the rear supported on narrow, cast-iron pillars. Vulliamy would have been known in the town as he had recently designed the Grand Stand at Wolverhampton Racecourse (see 21. West Park).

The Assembly Rooms were used through the 1830s and 1840s for dances and public functions. Gas lamps installed in 1837 replaced candles. The meetings of the first Wolverhampton Municipal Council were held here from 1848 onwards. In 1857 the library moved into a new building in Waterloo Road – now demolished.

Below left: Subscription Library and Assembly Rooms in Queen Street. (Photo from Joseph Jones, *Historical Sketch of the Art and Literary Institutions of Wolverhampton* (London: Alexander and Shepheard, 1897))

Below right: The (now) County Court building in Queen Street, seeking new uses.

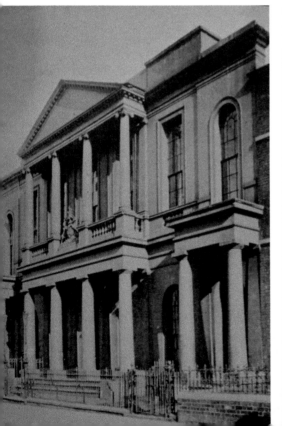 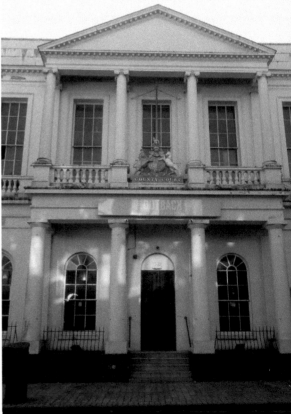

This building was sold on for use as a county court for the next 120 years. The county court joined the magistrates' courts in 1978 in the Old Town Hall in North Street, vacated when the new Civic Centre was completed.

In the early 2000s this building found a new life as a café-bar, Chancellors, then as the nightclub Walkabout, which closed in 2015, and most recently as Outback, which lost its licence in early 2019.

9. Dispensary, No. 46 Queen Street (1821)

Medical provision for the poor of Wolverhampton became urgent during the first two decades of the nineteenth century. After the French Revolutionary Wars of 1792–1802 ended, ironworkers were discharged, and many were out of work and destitute. They had no money to pay for their medical care.[8]

In 1820 a local surgeon, John Freer Proud, urged the establishment of a dispensary in the town 'for the preservation of the health and strength of the sick poor'. Donations and subscriptions came in. A house in Queen Street was bought for a Wolverhampton public dispensary, and a resident surgeon and apothecary appointed. The meeting in May 1821 appointed the dispensary's president and six vice-presidents. William Hollins, architect of Birmingham, was thanked for providing designs free of charge.

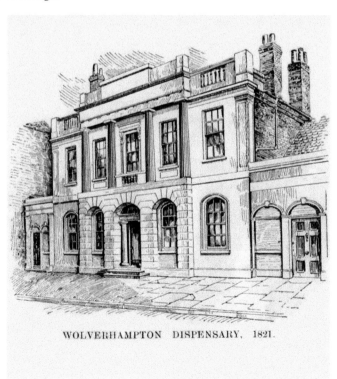

Wolverhampton Dispensary as first built. (Drawing published with permission from the collection of Neil Fox)

WOLVERHAMPTON DISPENSARY, 1821.

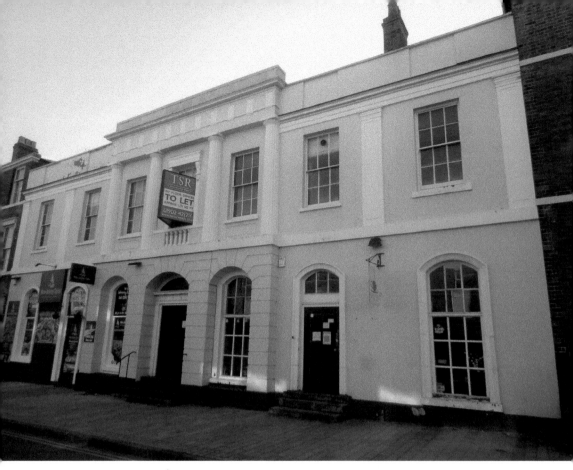

The current dispensary frontage on Queen Street.

By 1826, the dispensary had a new building, its frontage design very similar to Hollins' larger-scale public offices in Moor Street, Birmingham, opened fifteen years earlier.

The dispensary was in huge demand. It had six beds and there were nearly 100 patients per week on its books. More space was needed. Funds were raised. and the building extended to add a further fourteen beds – possibly by extending the single-storey bays at each end to two storeys. It was extended again in 1833 with casualty wards for sixteen patients built behind the main building.

From 1845 onwards it was clear that a full-scale hospital was needed. Funds were raised and the Staffordshire General Hospital in Cleveland Road opened in 1849 and the dispensary moved there (q.v.).

The building was next rented for three years as a first orphanage in Wolverhampton, a response to the 1849 cholera outbreak in the town. It became Wolverhampton's main post office from 1855 until the 1870s when the post office moved up the street to No. 55 (now redeveloped into the *Express* and *Star* buildings). Subsequently it has been used as National Coal Board offices, as a bar and as an Indian takeaway. Some fine details survive – for example, the main doorway – but this is another building that needs new uses.

1C. St Peter and St Paul's Catholic Church, North Street/Paternoster Row (1828)

Bishop John Milner (1752–1826), commemorated by the blue plaque on the side of the entrance doors, lived at Giffard House (q.v.) at the end of his life and worked for Catholic emancipation in England. Success came after he died with the Catholic Emancipation Act of 1829. He had already asked architect Joseph Ireland to prepare plans, extending the existing chapel at Giffard House to create a new church.[9]

The church was built with Milner's bequest of £1,000 for the new building. Outside, it's very modest, originally hidden behind street frontages alongside Giffard House. There are two welcoming statues of saints Peter and Paul over the entrance. Otherwise, the views of the church from Paternoster Row are plain stucco with moulded window surrounds and some minimal pilasters. At the ring road side, the 1920 extensions are even plainer – in red brick with slate roofs (see Giffard House photo p. 17).

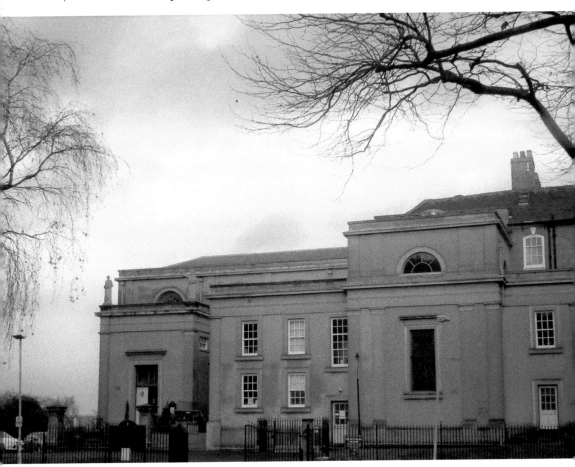

The outside of St Peter and St Paul's Church, once hidden behind other street frontages.

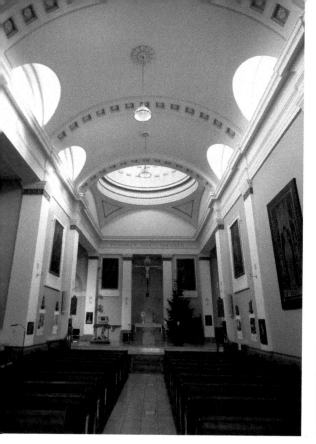 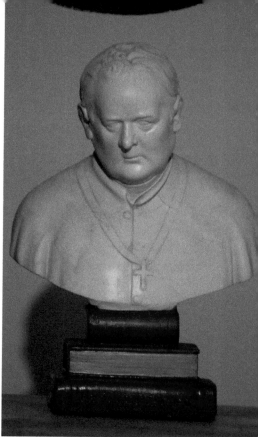

Above left: The nave of St Peter and St Paul's, with its award-winning altar furniture and crucifix above. (Included with thanks to Mgr Mark Crisp, Parish Priest, St Peter and St Paul's)

Above right: Bishop Milner, the founder of this church – image in the church crypt. (Included with thanks to Mgr Mark Crisp, Parish Priest, St Peter and St Paul's)

There is no hint of the superb interior of the church. The entrance leads through to Joseph Ireland's domed nave, lit by shallow-arched lunette windows, hidden from outside behind the parapet. Giffard House's private chapel became the domed bay above the altar.

Architect Edward Goldie created the full south chapel in 1901. The Lady Chapel, in Greek Revival style, was added in 1921 by architects Sandy and Norris, who also provided new access to a crypt with a bust and a sarcophagus for Bishop Milner. Milner remains buried however in the former Giffard House orchard, deep beneath the nave of the church.

Church arrangements change as time passes. The original high altar is now at the north side of the nave. Its 1989 replacement is in the Lady Chapel. The Ecclesiastical Architects and Surveyors made their President's Award for the 2009 church layout reordering, a new set of altar furniture sculpted in grey marble by Katherine Worthington and a wooden crucifix above by Rory Young.

11. Mechanics' Institution and Athenaeum Building, Queen Street (1836)

Local bankers, free church ministers, manufacturers, and a surgeon founded the Wolverhampton Mechanics' Institute in 1827. 'Improving' working men was a national enthusiasm at this time, with the first institutes started in 1823 in London and Glasgow. Objectives included providing lectures backed by libraries, newsrooms and reading rooms.

They first rented a private house in King Street, then completed the Mechanics' Institution in 1836 on undeveloped land in Queen Street. One of the institute's trustees, William Walford, was the 'architect', although he was possibly only an amateur – no other buildings by him are known. The Wolverhampton Subscription Library, also in Queen Street, (now County Court building q.v.) had recently been increased in 1829 to two storeys. Roper (1957) suggests it could have influenced Walford's design.[10]

The institution had to be funded from shares and subscriptions. Local interest quickly dropped off and subscriptions from users fell into arrears. By 1845 the library and newsroom were practically closed (J. Jones, 1897).[11]

In 1847 new subscribers relaunched the building as the Wolverhampton Athenaeum and Mechanics' Library, but by 1868 it too had failed. Wolverhampton

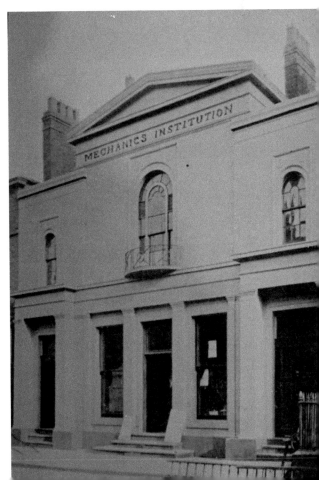

The original Mechanics' Institution before upstairs windows were added. (Photo from Jones, Joseph, 1897 op. cit.)

Corporation was founding the first Free Library for the town. The Athenaeum contributed its library and for three years this building was its first home. The permanent Free Library opened at Garrick Street in 1872. This Queen Street building then became the Workmen's Conservative Club. It has now been the Army Recruiting Office since at least 1921.

The building has lost some detail over its life so far. The original pediment and the Mechanics' Institution name have gone. Two smaller windows have been added on either side of the original lecture room's large arched window.

The blue plaque on the right of the building commemorates George Wallis FSA, who taught art around 1838 for the original Mechanics' Institute. As a young man, professional designer Wallis decorated Japanned ware for Wolverhampton

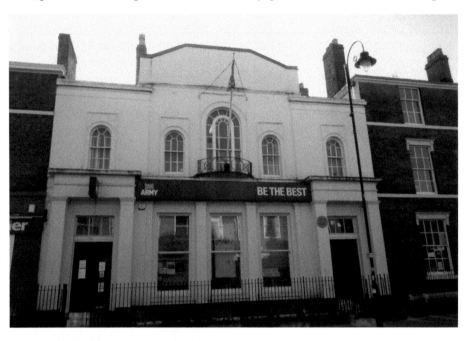

Above: The army recruiting office, as the Mechanics' Institute building is now.

Left: George Wallis, art lecturer at the institute in the 1830s. (Image from Jones, Joseph, 1897 op. cit.)

manufacturers Ryton and Walton. He later became a deputy commissioner of the 1851 Great Exhibition in Hyde Park, London, and a senior curator at the Victoria and Albert Museum in London.

12. Queen's Building, Pipers Row (1849)

The Queen's Building was Wolverhampton's High Level railway station's gateway, opened in 1849 by the Shrewsbury & Birmingham Railway. The central arched windows, originally open as carriage arches, led through to a 220-yard carriage drive to the station itself. There were side arches for people on foot.

The building was designed, together with the station itself, by the railway company's architect, Edward Banks. Banks (1817–1866) was very active in the town as a councillor and magistrate. He designed or contributed to designs

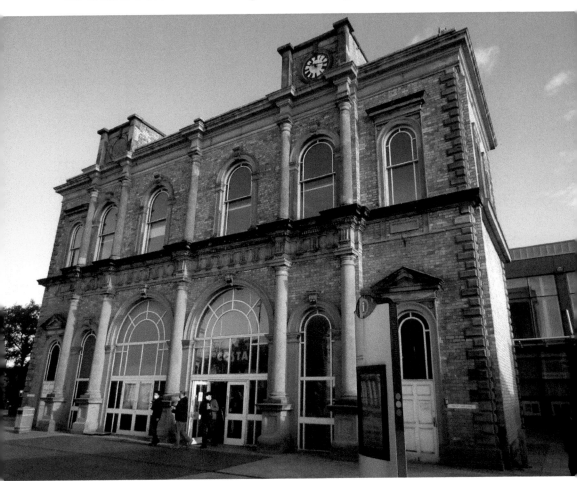

The Queens Building with former carriage arch windows, now Costa Coffee.

for various Wolverhampton and other nearby buildings, including the Royal Hospital (q.v.).

Over the years, the Queen's Building was progressively cut off. In 1890 Railway Drive created a main station approach bypassing it. Ring Road St David's, built in the 1980s, destroyed the original carriage drive. The council purchased the building in 1986 and for a while it was the entrance to the bus station.

The council's attractive new footbridge opened in 2011. Canopy-roofed and walled with stained glass to shelter from rain and wind, it recreates the carriage drive. The Queen's Building once again marks the entry to the town from the station.

13. The Royal Hospital, Cleveland Road (1849)

These buildings opened in 1849 as the South Staffordshire General Hospital and Dispensary, paid for by subscriptions from local business people. There were eighty beds. Subscribers reportedly paid 7 guineas (£7.35) for each bed. The architect was Edward Banks (1817–66) – see details of his career with the Queens Building (q.v.).

His competition-winning design for the hospital, as described by *The Builder*, was: 'in the Italian style with pressed red bricks and stone dressings. The principal front is 210 feet long and comprises a central building three stories high connected by two-storey portions to the two wings which are also two stories high…'[12] It's

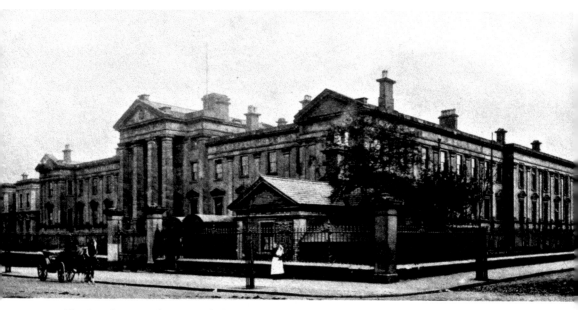

The Royal Hospital, as it was before the First World War. (Photo published with permission from the collection of Neil Fox)

The Royal Hospital central portico as preserved.

the building we see today, with the later Edward VII wing added in 1912, standing forward at the left end of the main frontage and in the same style.

There was no hospital provision in Wolverhampton before 1849. Earlier subscribers had paid for the dispensary, which eventually had thirty-six beds on Queen Street (q.v.), but it was completely inadequate to meet the demands of the growing town. Wolverhampton in the mid-nineteenth century had regular cholera outbreaks and other diseases from people living in large areas of insanitary housing. In due course, the hospital added many subsidiary buildings on the land behind this frontage.

From 1970, the hospital moved in stages to Heath Town. This site closed completely in 1997. It was first sold to Tesco in 2001 but in 2016 they pulled out. Homes England (then Homes and Communities Agency), the government's agency that recycles and redevelops derelict land, acquired the site, which included the former bus depot to the north of Cleveland Road.

The agency achieved planning consent. It awarded the redevelopment to developer Jessup in partnership with social and affordable housing provider WHG and Birmingham architects BPN. By late 2020 the bus depot's first phase was well advanced.

The hospital has been carefully secured with Perspex sheets over its windows and its attractive Victorian gatehouse lodge completely hidden under corrugated-iron protection. Any further phases of development, however, seem to be on hold.

14. Old Bank Chambers, Lich Gates (late eighteenth century) and St Peter's House (1852), Exchange Street

These two buildings are key elements of the backdrop to St Peter's Church. Old Bank Chambers completes the western side of the church's square of buildings and landscape.

Old Bank Chambers' asymmetry gives the design an informal feel. The first three bays fit with the main entrance doorway. The final two bays are thought to be the surviving part of a longer building. At its right end, beyond the steps that lead down to Exchange Street, was the original Wolverhampton 'Exchange' buidling – the town's Corn Exchange. When built in 1851, its line followed the far edge of the steps. St Peter's Chambers were cut back and refronted to line up with the frontage of St Peter's House at the bottom of the steps.

Old Bank Chambers in Lich Gates, the backdrop to St Peter's Church.

St Peter's House (right) and the refaced side of Old Bank Chambers (left).

Old Bank Chambers is now occupied by Thornes Solcitors, but was originally part of Cope's Wine Lodge, which occupied the whole of the block behind Nos 43/44 Queen Square.

St Peter's House was built also for Cope's some years later. Cope's is reputed to have used the cellars and ground floor for storage but let off upper parts as offices. The ground floor was changed to shops in due course: a butchers alongside the Bird in Hand's yard along Exchange Street and a wine merchants facing the market square.

The council bought the buidling in 1920, but sold it again to St Peter's Church in 1974. The purchase was in part exchange for the site of the old St Peter's School, behind the university's Wulfruna Street buildings, and is now developed as additional university spaces and buildings.

The church uses St Peter's House for its own functions, inlcuding a café and meeting place on the ground floor. It carries a blue plaque for Button Gwinnett. Originally from Gloucestershire, Gwinnett lived in Wolverhampton for eight years. He was married in St Peter's Church in 1757. In 1762 he emigrated to America. After reaching brief prominence in 1776, recorded on the plaque, he was killed in 1777 in a duel with bitter political rival Lachlan McIntosh.

15. Wolverhampton Grand Station (formerly Low Level Station), Sun Street (1854)

Grand Station in Sun Street was originally Wolverhampton's second main railway station, Wolverhampton Joint station, opened in 1854. It was planned by three railway companies, the Shrewsbury & Birmingham, the Birmingham, Wolverhampton & Dudley and the Oxford, Worcester & Wolverhampton. Their main line was a mixed broad- and standard-guage continuation of the Great Western London to Birmingham Snow Hill tracks. The buildings were designed by John Fowler and it had an overall roof by Brunel which lasted until the 1930s.

Eventually in the 1960s railway traffic was concentrated into the High Level station, now the main Wolverhampton station. The Low Level station closed in 1981 – the rail route from Birmingham lives on as the Birmingham–Wolverhampton Metro tramline.

The whole station site was acquired by the council in 1986. New flats have been built at the back of the station, but the council was keen to preserve main station heritage buildings. Finding a new use was not easy. A casino proposal received planning consent in 2006 but did not proceed. The Grand Station proposal was approved in 2011.

There are two banqueting suites for 500 or 130 guests built under the original platform canopies. The scale of the railway platforms at the back has been successfully recreated with black glass under the canopies and the original

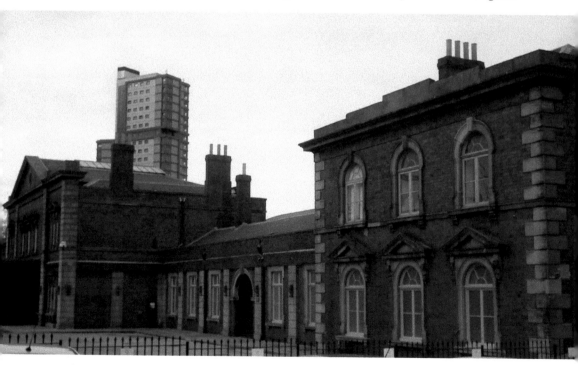

The original frontage of John Fowler's 1854 Joint station.

The Grand station renewal captures the feel of the original station.

footbridge remaining. The station booking hall has become the 'Old Ticketing Hall' – later ticket offices added inside have been swept away and the hall returned to its original two-storey splendour (now with an added chandelier). The black glass entrance lobby is less effective in daylight – submitted plans suggested it could be transparent to minimise its effect on the building behind. This has not really worked, but it does look entirely appropriate when fully lit up after dark.

16. St Mary and St John's Church, Snow Hill (1855)

In the early nineteenth century there was a growing Irish population in Wolverhampton. Additional churches were needed to follow St Peter and St Paul's in Paternoster Row. This was the first. Its architect was Charles Francis Hansom (1817–88). Trained by his older brother Joseph Hansom, architect and inventor of the hansom cab, Charles became an inventive and successful Gothic Revival designer in his own right. Although Bristol based, he was apparently

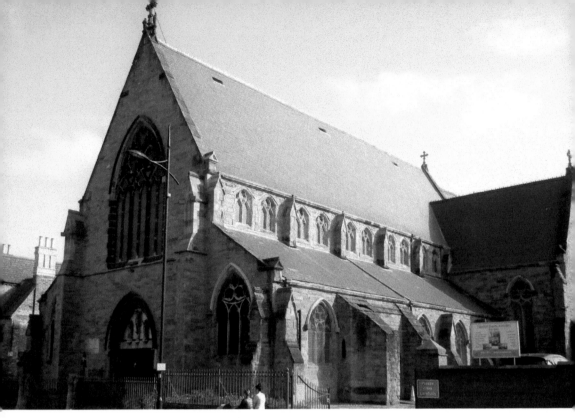

St Mary and St John's Roman Catholic Church from Snow Hill.

recommended here by Bishop Ullathorne, the first Bishop of Birmingham. Ullathorne had recently consecrated Hansom's Erdington Abbey church, which opened in 1850.

St Mary and St John's is in the Decorated style, dating from the early to mid-fourteenth century, and typically with large windows and flowing tracery, wide bay spacing and rich ornamentation. The church was enlarged by Hansom in 1879–80 in the same style with a six-bay chancel, a polygonal apse, side chapels and a baptistry at the eastern end.

The building is particularly impressive inside. The view through the nave to the stained-glass windows in the chancel is stunning. There is an engaging collection of architectural features throughout the church. At the start of each arch there are small head carvings of key people in the church's teaching – popes, kings and others in the nave and elegant pairs of Apostles with stone halos in the chancel. There are niches in the south transept with brightly coloured statues, a Madonna and Child on the left and St John on the right, believed to be of Flemish origin. The carving of the altar in Caen stone is attributed to Father Ullathorne, a priest at St Mary and St John's, and nephew of Bishop Ullathorne.

You can see stone carving close up on the intriguing double font in the baptistry. Stone figures are picked out in gold. Hansom provided a special new entry door

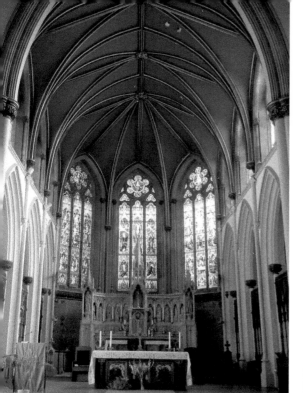

Above left: Inside the 1880 Chancel by architect C. F. Hansom. (Published with permission of the Roman Catholic Archdiocese of Birmingham)

Above right: Pair of Apostle heads on nave arches. (Published with permission of the Roman Catholic Archdiocese of Birmingham)

to the new baptistry from outside. Unbaptised children could enter the church appropriately with baptism to greet them.

Eastern European Catholics in modern Wolverhampton now swell the congregation and the church is thriving.

17. St Luke's Church, Upper Villiers Street, Blakenhall (1860–61)

St Luke's is an extraordinary church. With tower blocks in Blakenhall now demolished, it stands out again, a landmark from everywhere around it. The architect was Thomas Robinson of Leamington.

Up close, there is polychrome brickwork in what its listing describes as 'roguish gothic revival style'. The building details are superb. At each level the tower/spire has different window details. In its south-east corner a cylindrical stair tower with a conical roof is fixed to it. The main church has triangular openings in dormers at roof level. The windows have curved triangular edges and each is split into three glass circles. The brickwork is red for the main structure with jittery

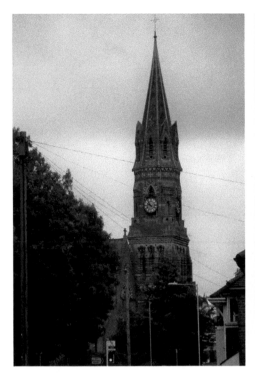 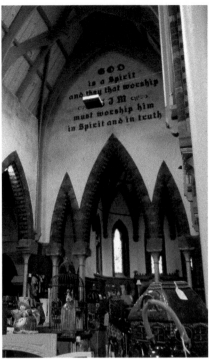

Above left: St Luke's Church spire from Lower Villiers Street.

Above right: Architecture and antiques inside St Luke's Church. (Published with permission of Dave Usher on behalf of Wolverhampton Antiques)

stone and yellow and grey brick details highlighting the porch, windows and gables.

The church is now used as an antiques market. Building details are preserved. There are Gothic arches on cast-iron columns, which is unusual at this period for Gothic churches – the Victorians expected their use restricted to industrial or institutional buildings.[13] Stained glass is still in place. There are decorated brick arches and decorative prayers painted on the plasterwork. The antiques are fun too.

18. Shipleys, No. 13 Queen Street (*c.* 1860)

This seems to be a complete oddity, a Flemish Renaissance frontage suddenly appearing at the end of a surviving traditionally styled row of mid-Victorian buildings. There is nothing comparable in Wolverhampton at this time. Dutch-style gables appear on later buildings, for example the 1900 block at Nos 19–23 across Market Street and further along Queen Street – a complete rebuild with large-scale floor heights.

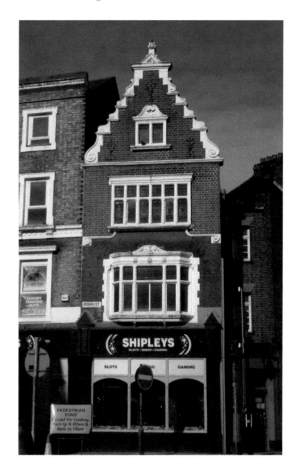

The Flemish house front of
Shipleys, Queen Street.

There is lively architectural detail on each floor above the modern shopfront.
The first floor has a fulll-width oriel window with stone mullions and a central
swan-necked pediment design. There is coloured glass in the upper window
segments. The second floor has a six-bay window with stone details and decorative
stone links from the bottom to the side walls of the building. The third-floor Dutch
gable has scrolled steps down each side, an onamented attic window with its own
miniature pediment and three decorative roof ties.

19. Old Town Hall, North Street (1871)

This is a French Renaissance 'second empire'-style building, fashionable in Britain
in the 1870s. There is a fifteen-bay symmetrical frontage. Two-bay wings stand
forward at each end and there is a central ornamented entrance bay with a clock
at roof level. The frontage was built of Caen stone with a special provision made
in its budget for £1,000 additional costs further to the £17,200 tender accepted.
The chateau-style pavilions on the roof were reportedly provided by the builder,

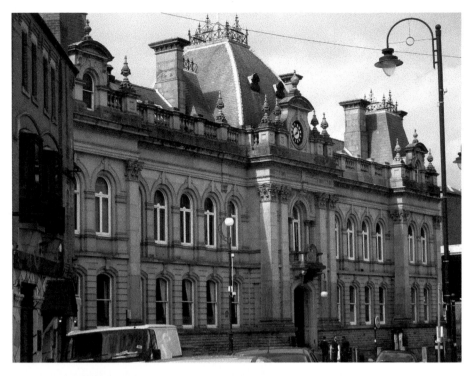

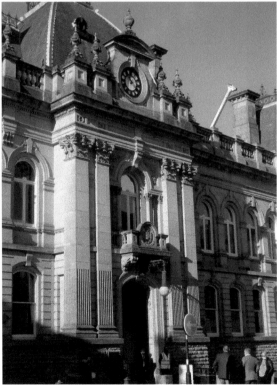

Above: Main frontage of the Old Town Hall's magistrates' courts.

Left: Entrance and central clock bay, Old Town Hall.

Roof, left-end pyramid,
Old Town Hall.

Philip Horsman, at his own expense.[14] At each end there is a square, straight-sided
pyramid, truncated at the top with ornamental ironwork. The bulbous convex-
roofed pavilion at the centre is especially grand with inset bull's-eye windows at
high level and branching side extensions, again with an ornamental topping.

The Town Hall provided replacement accommodation for municipal functions
in the previous town hall on this site and scattered across the town. In 1865 the
council agreed to pull down the old Town Hall and to consolidate a large site
between North Street and Red Lion Street behind for its replacement. Architects'
proposals were invited and Manchester architect Ernest Bates was selected. The
builder, Philip Horsman, was a local who later funded building the town's new art
gallery (q.v.).

The design included the council chamber, large rooms for committee meetings,
members' rooms, offices for council staff and a mayoral suite with a reception
room. Courts, which had been at Garrick Street, were consolidated here with
space for the sessions court, the borough magistrates' court, and rooms for the
recorder, magistrates' clerk and witnesses. There were detention cells beneath the
building for defendants awaiting hearing. A new large courtyard on Red Lion
Street housed the police offices and a fire station.

Civic functions moved out when the new Civic Centre was completed in 1978.
The building was used at the town's law courts until Crown Court functions
were moved to new buildings in Pipers Row. The magistrates' court continues to
operate here.

20. Barclays Bank, Queen Square (1876)

Hordern, Molineux and Company is the earliest recorded bank here (1797), becoming the Wolverhampton and Staffordshire Banking Company in 1831. By the late nineteenth century, Wolverhampton city centre was going through massive changes. The previously narrow, half-timbered Lichfield Street was being swept away. Wolverhampton's 1875 Artisans' Dwelling and Street Improvement Act provided for a new roadway (for Lichfield Street), 37 feet wide with 10-foot-wide footways on each side. The bank acquired the buildings around it and planned this new building.

The architect was T. H. Fleeming, FRIBA 1849–1935. Very active in Wolverhampton, he later became the president of Wolverhampton and District Architects' Association. He worked on many Gothic churches, chapels, board schools and other buildings in the Black Country and into Shropshire. Fleeming's style here is Gothic too – the bank is almost a miniature Venetian Palazzo. There are some standard Gothic details. The ground floor has plain, flat-headed windows with a band of foliated capitals between them. Between the ground and first floor there is a substantial stone string course carved with foliage. The first floor has more elaborate pointed-headed windows with paired sandstone pillars on each

Below left: Barclays bank standing out in the city centre.

Below right: The romantic eastern end to Barclays.

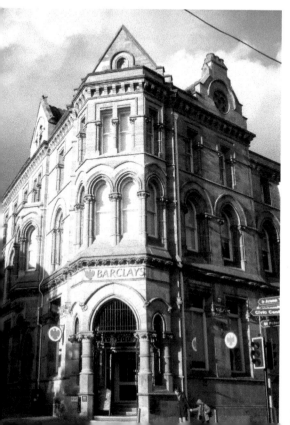

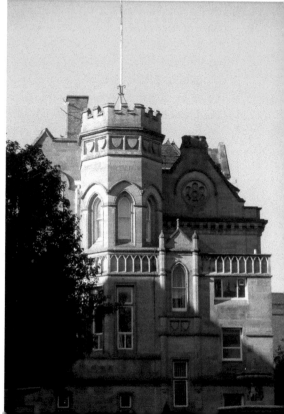

side of them. The top floor retains the sandstone pillars but has smaller straight-headed windows. At roof level there is a carved cornice. The façades and rooflines are broken up with highlighted bays with decorated gable ends.

The bank's east-facing façade is a theatrical endpiece to the building, completely unlike a bank. There is a romantic octagonal castellated (staircase) turret and picturesque additions facing onto St Peter's Gardens. There are two storeys of blind arches on the flank wall at the Lichfield Street side. A Gothic arch frieze around the turret is broken by a narrow two-storey bay flanked with Gothic pilasters and with its own tiny triangular gable. Above and behind is the flank wall of the larger bank building with its cornice continued round and a final blind rose window in the gable end.

The Wolverhampton and Staffordshire, by then the United Counties Bank, eventually joined Barclays in 1916.

21. West Park (1881)

West Park was originally marshy waste ground beyond the edge of the town. Partly drained, it was used as the town's racecourse from 1825 on a lease from Lord Darlington (later the Duke of Cleveland), who also owned the land where Darlington Street was laid out.

Victorian opinion had turned against racing – 'an adverse moral influence on the population'[15] – by 1878 when the lease expired. The council bought a sixty-three-year lease for the town's first park. Their competition specification called for picturesque landscape framing space for sport and for formally laid out gardens, a style pioneered by French park designer Edouard Andre (1840–1911). He had worked for the Polish and Lithuanian aristocracy and recently, in 1872, had completed Sefton Park in south Liverpool.

The competition was won by Richard Hartland Vertegans, nurseryman of Chad Valley Nurseries, Edgbaston, with a design providing for archery, cricket, bowling and volunteer drill as well as scenic planting. The park opened on 6 June 1881. Its figure-of-eight lake, essential to drain the remaining swampy land, was spanned by a cast-iron bridge built to the borough engineer's designs by Messrs Bradney and Co. The four-faced cast-iron clock tower, donated in 1883, and the statue by W. Theed of Charles Pelham Villiers, one of the town's first pair of MPs after the 1832 Great Reform Act, stand among the planting beds on either side. Villiers reputedly never visited Wolverhampton, but he donated the original bandstand – extended in the 1900s with a new circle of columns and roof around the original structure. Across the lake is the park's architectural highlight: the superb glasshouse, designed by Arts and Crafts architect Dan Gibson. Following restoration in the mid-1990s, it is a rare survival of a Victorian timber structure still in use.

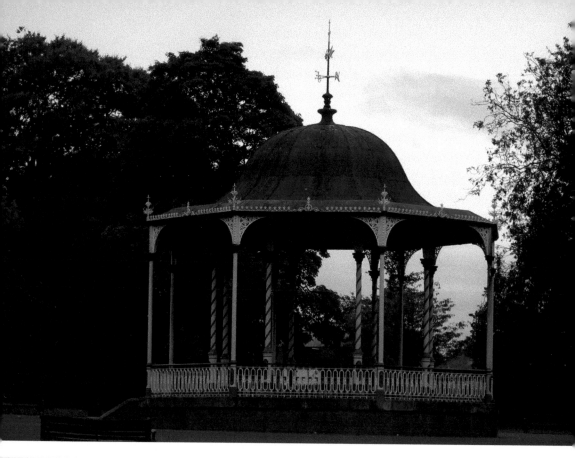

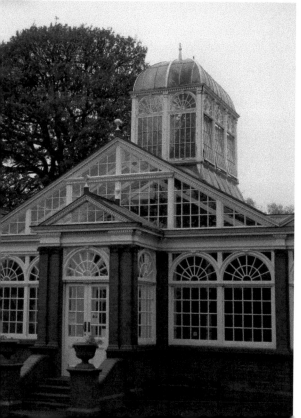

Above: West Park bandstand was enlarged in the 1900s.

Left: Architect Dan Gibson's glasshouse at West Park.

The park needs constant attention. Its trees were ravaged by Dutch elm disease in the 1970s and replaced with new species now grown to maturity. Heritage Lottery funds provided complete refurbishment in the early 2000s. Further restoration of the glasshouse continues in 2021.

22. Lloyds Bank, Queen Square (1883)

The bank was designed by Lloyd's principal architect J. A. Chatwin (1830–1907). He had trained with Charles Barry, architect of similar style Italianate clubs in Pall Mall in London (as well as of the Houses of Parliament).

Chatwin makes fluent use of standard classical details in the ashlar stone frontage. There is a Doric-pillared porch and tall, plain windows on the ground floor. On the upper floors there are rectangular windows with round pediments on the first floor and round-headed windows on the second. The third floor has smaller round-headed windows.

The bank advertises its contributions to the local economy with carved panels above the ground-floor windows. There is coal mining on the left panel, with miners excavating a coal seam and loading trucks. The middle panel covers farming, cutting and pitching hay onto a horse cart and pausing at the left for quick refreshment. The right panel shows heavy industry, steel casting and milling. Sculptural panels

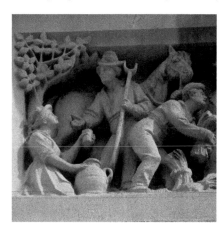

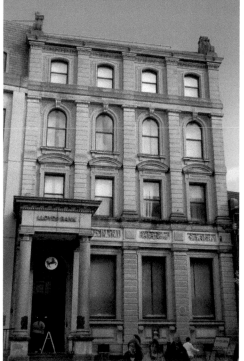

Above: A reminder of pre-industrial Wolverhampton at Lloyds Bank.

Right: Lloyds Bank, an elegant classical building in Queen Square.

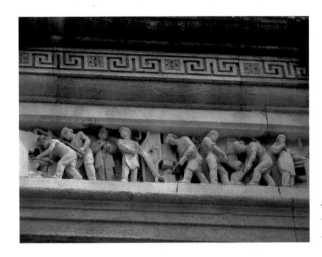

The industrial base of Wolverhampton's banking wealth.

seem to be a Chatwin speciality at this time. They are also a major feature on his Wolverhampton Art Gallery completed the following year (see next section).

The bank has a colourful history leading up to this very respectable building. Richard Fryer was originally the licensee at the Cock Inn in Berry Street. A 'military man' left a chest for safekeeping with Fryer in 1745. He never returned for it. Sixty years later, Fryer's sons opened the chest and found it full of French gold. In 1807, using this capital, they moved from brewing to banking and founded private bank R. & W. F. Fryer. Richard Fryer became one of the first pair of Wolverhampton MPs, from 1832 to 1835. His son, William Fleeming Fryer – the surviving director when the bank was absorbed into Lloyds in 1872 – became a director of Lloyds.

An extension building has been added alongside but in a bland 1970s style.

23. Wolverhampton Art Gallery, Lichfield Street (1884)

On 5 November 1881 Wolverhampton builder Philip Horsman wrote to his friend, Mayor John Jones:

> I see that you have started a subscription for an Art Gallery in the town …
> I propose to erect and present to the Town a building of the value of £5,000 upon the following conditions:
>
> First, the Town to provide a suitable site with provision for enlargement
>
> Second … gentlemen in the neighbourhood to contribute works of art …
> When you have promises to the extent of £10,000 … I am prepared to begin the building.
>
> Third, … no-one except yourself and me know the name of the giver.[16]

The offer was accepted and the mayor preserved Horsman's anonymity.

The council was already acquiring land under slum-clearance powers, the Wolverhampton Artisans' Dwelling Act of 1877. Art bequests came from Maria Cartwright, whose husband had just died; Horsman and Jones made gifts too.

Horsman worked with architect Julius Chatwin (see also Lloyds Bank, q.v.). The gallery is a fine addition to the space around St Peter's Church. There are grand entrance steps, a porch with pink granite columns and a further two-stage portico. There are windows into the ground-floor galleries. At first-floor level, Portland stone reliefs personify the arts – women on the left and men on the right. Further reliefs overlooking the gardens portray Industry and the Sciences on two panels separated by a second grand entry, originally into the School of Art. First-floor galleries are brilliantly lit from clear-glazed rooflights.

Architect Tim Rolt's 2007 extension infilled an open courtyard and provides a bright-white new circulation space and stairs. Galleries beyond were planned initially to showcase the gallery's Pop Art collection – one of the best in the UK outside London.

The gallery has engaging displays, a lively mix of modern paintings and sculpture together with its older Victorian and classical holdings. Philip Horsman, finally named as benefactor a year after the gallery opened, has his own memorial alongside – the 1894 fountain in St Peter's Gardens donated by the town.

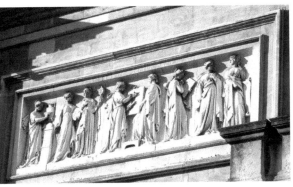

Above: Sculptor Richard Lockwood's female artists to the left of the entrance bay.

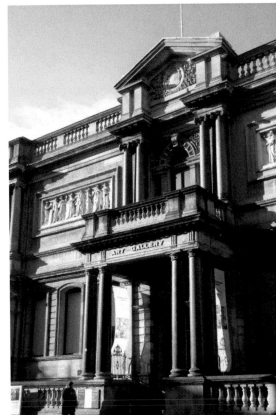

Right: Wolverhamton Art Gallery, cultural ambitions alongside commerce and industry.

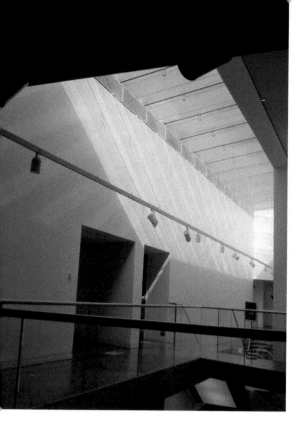

Bright light in architect Tim Rolt's 2007 gallery extension.

24. Grand Theatre, Lichfield Street (1894)

C. T. Mander, Mayor of Wolverhampton, was the head of the group organising the development of the theatre. They bought land that stretched through from Lichfield Street to Berry Street, next to the Victoria (now Britannia) Hotel, which had opened in 1890. The Mayoress, Mrs Mander, laid the foundation stone on 28 June 1894. *The Builder* reported: 'The theatre will be divided into five classes of audience, all classes of the audience being kept apart.'[17]

The Grand Theatre was a rapid build. It was ready to open on 10 December within six months of its foundation stone being laid. Architect C. J. Phipps (1835–97) is commemorated by a blue plaque alongside the entrance. He was one of the two nationally respected theatre architects of his time. This was apparently the seventy-fourth theatre that he had designed; he regarded it as one of his most successful.[18] Wolverhampton-born Henry Gough was the builder. The whole theatre was richly decorated with white and gold plaster moulding and claret wallpaper and curtains.

The first show was Gilbert and Sullivan's operetta *Utopia Limited*. D'Oyly Carte Opera played to a packed house of 2,150 people. There were two private boxes for ten people that cost 1 guinea each (£1.05). The 231-seat Dress Circle was for the gentry who had grand stairs up from the entrance. Their Dress Circle Lounge was behind the arches on Lichfield Street. Gallery spaces were 6*d* (2½p) – 700 people shared an open-air balcony in the intervals.

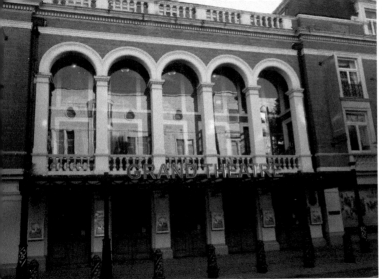
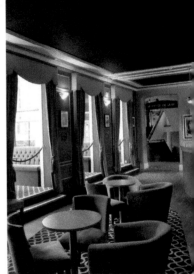

Above left: Architect C. J. Phipps's Grand Theatre, Lichfield Street.

Above right: Interval relaxation – the Grand Theatre's refurbished first-floor bar. (Published with permission of the Grand Theatre)

The Grand's career has had its challenges. The council purchased the theatre for £74,000 in 1969 to fund refurbishment. Despite the relaunch audiences declined, and the theatre closed in 1980. A 'Save the Grand Action Group' was successful, and the theatre reopened in 1982 with grant funding and council subsidy. A full £8 million Lottery- and European-funded refurbishment by architects RHWL and contractor Bovis, was completed in 1998. The auditorium is back in Phipps' original colours. There are 1,200 new seats and a new bar on each level – a bit more egalitarian than the original 1894 arrangements.

25. Old Post Office, Nos 29–51 Lichfield Street (1895)

This building was the head post office of Wolverhampton from its construction until the 1960s. It is the work of government architect Sir Henry Tanner (1849–1935) in the northern Renaissance style. Winner of the RIBA Classical Architecture Tite prize in 1878, Tanner worked as surveyor, first class, for the *Post* and *Telegraph* services from the mid-1880s. Before this building, his post office buildings included York (1885) and Birmingham (1889-91). His Birmingham post office in Victoria Square was in the same style but having a more restrained overall effect in uniform stone without the yellow terracotta and red-brick contrasts here.

Behind its current neglect, this remains a striking building, a vigorous display of late Victorian confidence. In its centre, there is an impressive entrance: a porch with Corinthian pillars carrying two lions with shields, flanking a larger coat of arms with its own pediment. At roof level, balustrades lead to a central feature, the royal coat of arms with a semicircular shell pediment above.

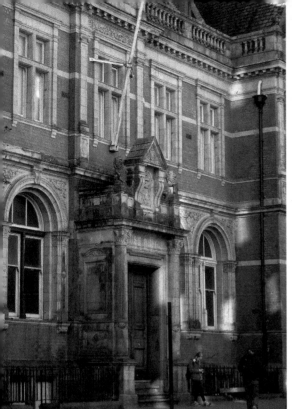

Above left: Red-brick and terracotta highlights: the old post office.

Above right: The old post office's cupola, a miniature classical temple.

The two-storey main elevation has five bays. Beyond, there are massive three-bay, three-storey gables stepping forward. After each gable is a final two-storey single bay with balustrades and single dormer windows in their roofs. The gables each have their own pediment above double-arched windows at the third-floor level. The construction is in red brick with a riot of terracotta mouldings from specialist supplier Ruabon Brick and Terracotta Company. At the rooftop is a crowning white, two-level octagonal cupola with a small, ribbed, dome roof.

The post office moved next door to No. 66 in the 1960s. This building was used for a period by the university but was empty again in 2007 and awaits a new use.

At the left-hand end of the building, the blue plaque commemorates Sir Rowland Hill, who lived briefly as child on the edge of Wolverhampton. He and his wife married in the town in 1827 but moved back to London and fame with the invention of the penny post and the penny black stamp in use from 1840.

26. Chubb Building, Railway Street (1899)

Chubb bought this site from the corporation after slum clearance and established its factory here in 1899 with space for 350 lock makers and 350 safe makers. This

was the headquarters for a business that had a national coverage. They used their prominent location to advertise the works across three main frontages in individually made porcelain letters more than 2 feet high. The turret in the top corner was originally crenelated, highlighting a fortress image for the whole building.

The architect was Charles Henry Mileham of London (1837–1917), whose principal interests were picturesque country houses, churches and schools. This seems to be his only factory.[19] He was assisted by superintending architect F. T. Beck of Wolverhampton.

In the early nineteenth century, lock makers Charles and Jeremiah Chubb had moved to Wolverhampton – at that time the national hub of the English locks industry. They brought a national reputation, built on Jeremiah's competition-winning, unpickable padlock design. By mid-century, they were a premier lock and safe manufacturers, working for royalty and providing a secure display for the priceless Koh-i-Noor diamond at the 1851 Great Exhibition.

Their manufacturing had been located at various sites around the town before the Chubb Building. Later they moved on and consolidated manufacturing in Heath Town on the edge of Wolverhampton. They sold this building to industrial steam systems manufacturer Baelz. When in 1978 they too relocated, the Chubb Building became empty.

The borough council and Midlands Industrial Association stepped in. They used Robert Seager Design to create a series of small office suites aimed at creative

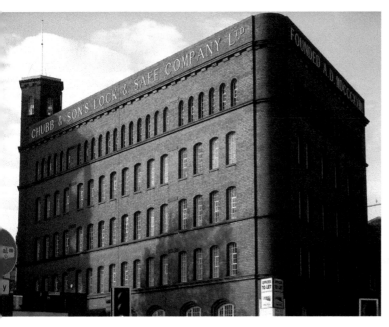

Above left: Chubb & Son's former factory in Railway Street.

Above right: Chubbs' fortress turret, now reduced to a copper roof and flagstaff.

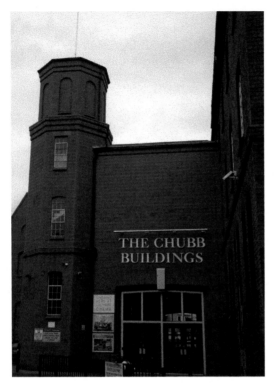

Light House Media Centre's
entrance and accompanying
lighthouse-shaped tower.

start-ups – marketing compares the location with Shoreditch and Hoxton. The Light House Media Centre, a joint council and University of Wolverhampton (then Polytechnic) initiative, moved in 1991 into their addition to the building. There is a signature brick lighthouse at its corner. There are three galleries and the only independent cinema in the Black Country. The courtyard space with a steel-framed glass roof is now an attractive central circulating space for the whole building with a café-bar and a bookshop.

27. The Prince Albert, Railway Street (1900)

The Prince Albert pub was built as a railway hotel close to the two Wolverhampton railway stations. It benefited from Railway Drive, cut in the 1890s to join the new Lichfield Street, as a direct access from the centre of town to the High Level station. It was also on Railway Street, the carriage link from the town towards the road bridge under the railway towards the Low Level station.

The building was designed to be a landmark seen from the railway station, a formal symmetrical elevation with bays and cupolas at each end framing a four-bay central structure. Times have changed. People visiting Wolverhampton no longer look first for a hotel and the Prince Albert is now hidden behind the major new i9 office building immediately across the street. Its entrance is from the Fryer

Above: The Prince Albert's original frontage.

Right: Prince Albert's doorway and carved stone details.

Street side of the building through a garden. It seems to be creating a new identity as a successful cocktail bar. The architectural details are still in place – you now have to look carefully for them at the Railway Street side of the building.

28. Methodist Church, Darlington Street (1901)

This building is now a striking end point on the Darlington Street route downhill out of the city centre. From higher up the road you can see the huge dome. As you approach, the red-brick and stone detail frontage with its two giant cupolas dominates. The church, initially Darlington Street Wesleyan Chapel, was built in 1901. Its architect was Nottingham-based Arthur Marshall, 'the most interesting Arts and Crafts Architect [in Nottingham] at the time'.[20]

The building is in an Arts and Crafts influenced Edwardian baroque. Rusticated stonework is carved in high relief. On the frontage above double entry doors, there is a central Venetian window with tall single windows on each side; each has a carved balustrade below. The three-stage cupolas on their square towers have concave cut-outs with an urn on each corner and rise to a distinctive dome and pinnacle. Along each side of the chapel the single windows continue, ending with another Venetian window. The green copper dome is a Wolverhampton landmark held up on its circle of small windows punctuated by larger pedimented windows on each compass point. Behind the building the Victorian tower with its decorative ironwork cresting survives from earlier nineteenth-century communal buildings.

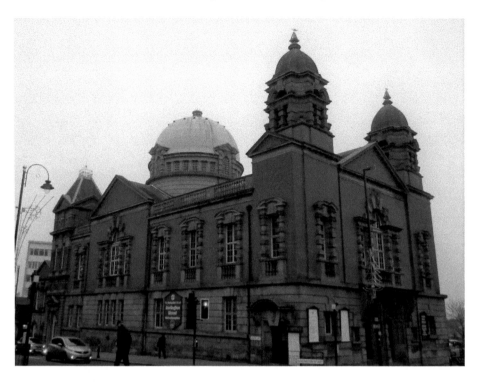

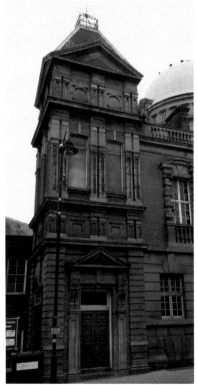

Above: Darlington Street, former Methodist Church.

Left: Methodist Church Victorian tower surviving from earlier buildings.

Methodism has had a fiery history in Wolverhampton. In 1745, open-air preachers reached the town and John Wesley himself preached on the village green at Bilbrook, just outside Wolverhampton. Wesley preached again at High Green in the town centre (now Queen Square) in 1760. In 1762, the first Wesleyan Methodist meeting house opened in Rotten's Row (Broad Street). In 1763, the meeting house was attacked by a mob and burned to the ground. The mob leader, Mr Hayes, a lawyer, was forced by local landowner Lord Dartmouth to rebuild the meeting house at his own expense.

The year 1901 may have been a high point for the movement. By the twenty-first century the church was losing its congregation and had to close in 2019. As this is written a new use is still being sought.

29. Royal London Buildings, Princes Square (1902)

Princes Square was created as part of the new road layout following clearance for the Wolverhampton 1877 Artisans' Dwelling and Street Improvement Act. Slums, including the notorious Carribee Island just north of Princes Square and east of Stafford Street, were swept away. Land around Lichfield Street was cleared for road widening to create an 1880s modern city.

For this final cleared site, Birmingham architects Essex, Nicols and Goodman created the Royal London Buildings in an intricately carved Edwardian baroque style. As you approach along Lichfield Street, its cupola frontage closes the view along the street.

As you get closer the complexities of the elevations on each side become clearer. Each has a curved façade that builds up to the tower and the cupola. Each segment has shopfronts at street level. The first and second floors have bay windows between eclectic Ionic-style giant columns. The columns end with a string course that continues around the whole building above the second-floor windows. Above it, there are three dormers at the roof level of each quadrant each with its own attached columns and a curved broken pediment. An urn on an upstand separates each dormer.

Between the two quadrants is the entrance tower. Its squat archway, supported on short pillars, carries glazed terracotta panels by Carters of Poole with swags and roundels commemorating the Royal London Friendly Society (RLFS) and the building date of 1902. At roof level there is a balustrade with urns above and the eight-sided cupola.

The side frontages are less elaborate. Nos 11–17 Lichfield Street continue the bay window and column theme on the first two floors, rising to a plainer third floor and a two-window gable. Wulfruna Street has three storeys with simple square-headed windows and fourth-floor dormers at roof level.

The building was refurbished around 2000. The upper floors are now flats owned by local housing association Heantun. The shops continue at ground floor with their own individual styles. The 1880s improvement worked, and Princes Square feels like a real entrance to a city centre.

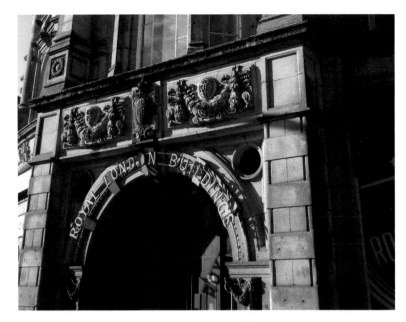

The decorated entrance arch to the Royal London Buildings.

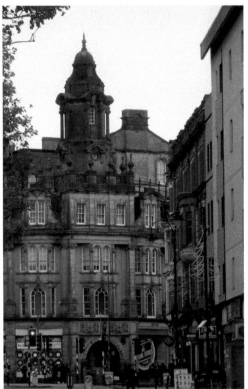

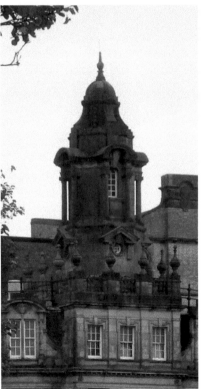

Above left: The Royal London Buildings, marking entry to the city centre.

Above right: Urns and balustrading surrounding the Royal London Buildings' cupola.

30. Central Library, Snow Hill (1902)

As Pevsner describes it, this is 'a delightful … building'.[21] It makes a decisive close to the rise at the top of Cleveland Street above the open-air market and the Wulfrun Centre.

Detailing is a free mix of baroque, Arts and Crafts and art nouveau influences with terracotta window mouldings and towers within a good quality red brick overall façade. The architect H. T. Hare highlighted an imposing corner entrance gable. The terracotta carvings are by prominent London craftsman William Aumonier. Towers with green domes stand like sentries guarding the gable and, above it, the spire emphasises the overall composition.

The main library accommodation is in the attractive side wings. There are inscriptions to famous British writers within the first-floor window mouldings. The ground floor, initially a spacious magazine room and now the main lending library, has a run of six fine arched windows. The shorter wing along St George's Parade has its own grand oriel window above four more arched windows.[22]

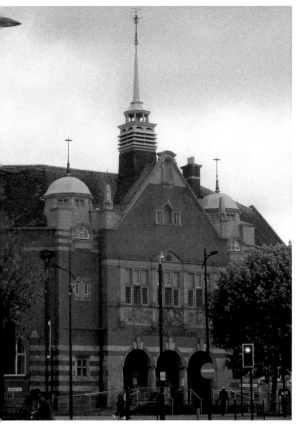

Above left: Architect H. T. Hare's Central Library frontage.

Above right: Central Library's Arts and Crafts windows, Old Hall Street.

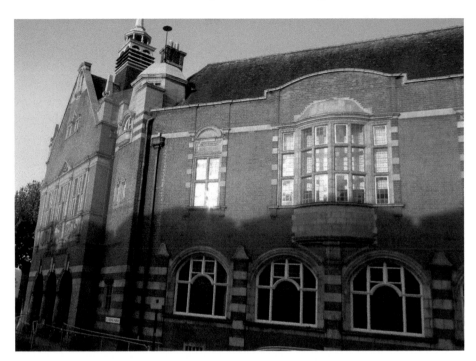

The grand bay window of the library on St George's Parade.

The building's opening in 1902 was the summit of thirty years of free libraries in Wolverhampton. The Public Libraries Acts of the 1850s set up a framework for funding. Wolverhampton adopted the Free Libraries Act in 1869. The Athenaeum in Queen Street (see Mechanics' Institute q.v.) gifted its own library's books. The Free Library started in their building on a three-year lease before moving to its new library in Garrick Street. From 1870 onwards the library built up its lending book stock to around 28,000 volumes, with 330 lent out every day. A total of 1,100 people a day visited the reading rooms and 1,200 students attended sixty-five classes in science, technical and commercial subjects.

The Free Library design competition required a newsroom and reading room on the ground floor and book stacks, the reference library, committee and librarians' rooms on the upper floor. Hare's successful competition entry was considered an outstanding use of the site. Varied façades faced the street. The building saved money with very plain brick rear walls.

31. St Silas Church (former Synagogue), Fryer Street/Long Street (1903)

In 1858, this was the first purpose-built synagogue for Wolverhampton. After a major fire in 1902, it was restored in 1903 (Hebrew calendar 5663, as shown on the front elevation plaque). The architect was Frederick Beck, who worked

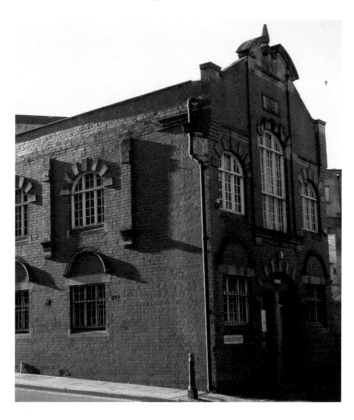

Church of St Silas,
the former
Wolverhampton
synagogue.

extensively in Wolverhampton and around (he also contributed to restoration
work for St Peter's Church).

The external elevations are largely as drawn by Beck. A ball finial has been lost
at each corner of the entrance frontage, and the parapet along Fryer Street was
added later. The right side and back elevations to car parks have been rendered –
they were originally concealed alongside other buildings now demolished. The
style is a minimal Ashkenazi Moorish style – a traditional synagogue style brought
from eastern Europe but referring back to a golden Jewish age in Spain in the
eleventh and twelfth centuries.

With the eventual decline in the local Jewish community, the synagogue was put
up for sale and acquired by the Church of England (Continuing). It is now St Silas
Church. There has been major external renovation to remove damp penetration
and make the building sound. Interior details from synagogue days have been
faithfully preserved by the new owners whose beliefs lean toward original
religious forms – the St James Bible, the Thirty-Nine Articles and the Book of
Common Prayer. The celebratory ark of the covenant remains with traditional
Hebrew abbreviations of the Ten Commandments above. It is accompanied
below by text from St John's Gospel. The double doors on Long Street originally
provided separated entries for men and women, and the segregated women's stairs
up and their upper gallery are still in place.

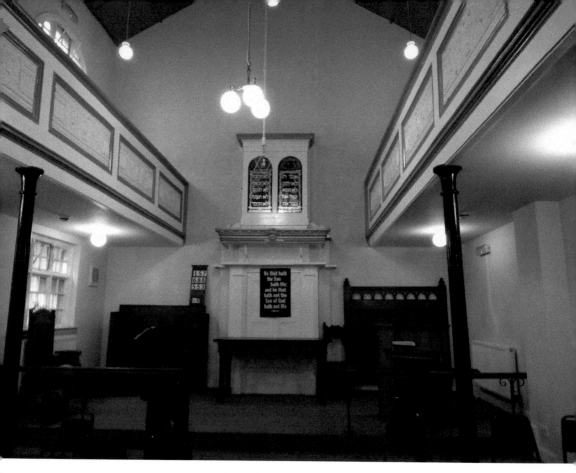

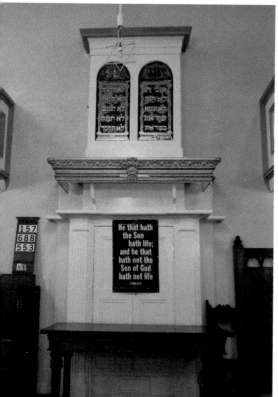

Above: Church and former Jewish Ark fittings. (Published with permission of the Congregation of St Silas COE (Continuing))

Left: Close-up of Church and Hebrew texts. (Published with permission of the Congregation of St Silas COE (Continuing))

There is also a Jewish burial ground, now closed, in Blakenhall where Cockshutts Lane meets Thompson Avenue. You can see it on aerial views, but it's completely hidden behind the Napier Road houses and an industrial estate. There are details with its Historic England listing but there is virtually nothing to be seen from outside.[23] Jewish heritage in Wolverhampton is very discreet in current times.

32. The Trocadero Building, Queen Street, Nos 29–31 (1904)

Built between 1904 and 1912, No. 31 Queen Street first appears as the Trocadero Public House in the 1912 Kelly's Staffordshire Directory.[24] It replaced three houses, part of the Georgian terraces on either side, but with much more generous floor heights and internal spaces. The distinctive red and brownish-red terracotta, typical of Wolverhampton's new buildings at this time, created sculptural shapes without the cost of hand carving each individual stone. The frontage echoes a traditional manor house design with bows at each end, Corinthian pilasters and a balustraded parapet topped with four ball finials.

By 1912, the wider shopfront space on the left was an outfitters, Target Clothing Company, and from 1940, the home furnishers Campbells. By 2020, it was split for Cash Generator and an entrance for the nightclub using the basement vaults. The Trocadero public house, Little Dessert Shop in 2020, took up the right-hand shopping space. Upper floors, originally offices, W. A. and H. M. Foster (solicitors) and Manifold (printers and wholesale stationers) in 1912, are now Old Trocadero Block Apartments, commemorating the original name.

Below left: The striking terracotta frontage of the Queen Street Trocadero building.

Below right: The Old Trocadero Block's entrance.

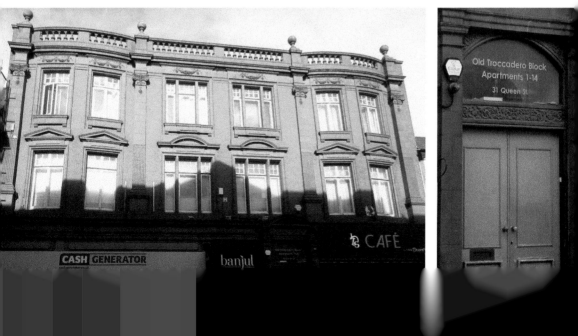

33. Former Sunbeam Car Factory, now Guru Teg Bahadur Gurdwara, Upper Villiers Street, Blakenhall (1905–06)

This building, Automotive House by Joseph Lavender, FRIBA, was at the heart of the developing Sunbeam car works on both sides of Upper Villiers Street. This building is reported to have provided offices showrooms and workshops for the company. The Sunbeam company was founded by John Marston (1836–1918). They made bicycles from 1877 at Sunbeamland factories (now student flats) at Pool Street, Wolverhampton. Marston purchased the former Blakenhall Tin and Japan Works, the factory behind this building, in 1898. He experimented with cars from 1901 onwards. The first cars were developed in the vacant coach house remaining from the original Moorfields house on this site.[25]

The long frontage of the main building has three storeys. The central entrance bay has a curved pedimented doorway and a small triangular pediment at roof level. The factory buildings with saw-tooth roofs survive at the back of this site. The extensive workshops across the road were developed as the Sunbeam car factory.

Automotive House is now a Sikh temple, Guru Teg Bahadur Gurdwara. The outside frontage onto Villiers Street has been refurbished. Inside, the showroom

Below left: Sikh temple in the former Sunbeam Cars HQ, Automotive House.

Below right: The entry into the temple, Guru Teg Bahadur Gurdwara.

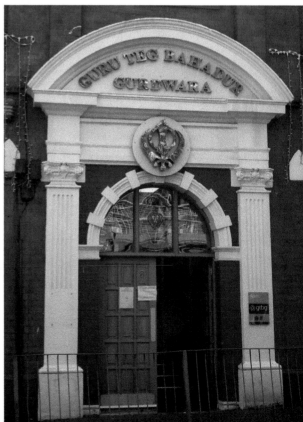

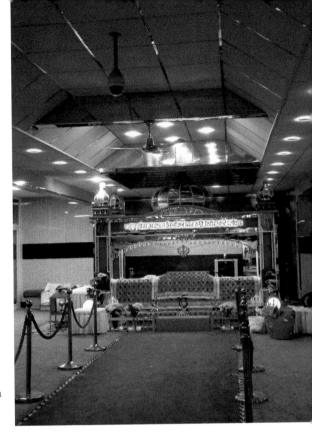

Sunbeam headquarters space reused as a Sikh prayer room. (Photo published with permission from Surjit Singh Uppal on behalf of Guru Teg Bahadur Gurdwara)

and factory spaces have been reused as prayer rooms. There is a large kitchen making food for people from the local community to come in for meals. At the 2011 census, Sikhs were the largest religious grouping in Blakenhall ward – 39 percent of the population. Plans were approved in 2016 for further development in the yard at the Park Street South end of the site to include a larger prayer room and a traditional temple-style domed roof. There was no work in progress as of late 2020, but this is clearly a vibrant community.

34. Former Department Store, Beatties, Victoria Street/Darlington Street (1920s)

Beatties used to be Wolverhampton's premier department store. James Beattie founded the Victoria Draper Supply Stores in 1877. From the east side of Victoria Street, Beattie relocated after a fire in 1896 to a new store opposite. The Victoria Street frontage was redeveloped in the 1920s by local architects Lavender, Twentyman and Percy, their design partner again for the 1950s extension in Darlington Street. The shop also acquired the curved corner shop that had been Burtons menswear.

The frontage to Victoria Street is impressive with tall arched windows and a semicircular setback at the southern end. The Darlington Street buildings are in a restrained 1950s classical style. The Burtons building has a Burtons standard

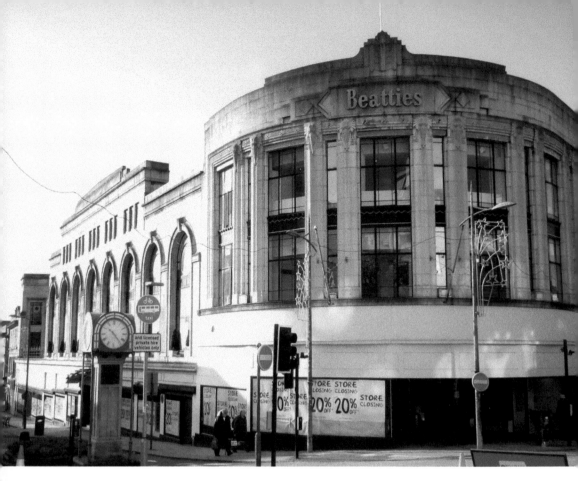

Above: The former Beatties store at the top of Victoria Street.

Left: Beatties' 1950s Darlington Street frontage by Lavender, Twentyman and Percy.

façade in an art deco style with elelphant head capitals to the frontage columns – a company speciality.

After takeovers by House of Fraser in 2005 and Sports Direct, Beatties' site was sold to investors in February 2020. House of Fraser is due to reopen in the former Debenham store opposite Beatties in the Mander Centre. It will not reuse the Beatties name. At the end 2020 the future of the these buildings remained open.

35. Wulfruna Building and the University of Wolverhampton, Wulfruna Street (1932)

The University of Wolverhampton started life as Wolverhampton and Staffordshire Technical College on this site. The council had acquired the Old Deanery and its grounds in 1912 and demolished the building in 1921.

The major frontage building was started in 1931 with its foundation stone laid by Prince George. It opened in 1932. The architect was Colonel G. C. Lowbridge, Staffordshire county architect, building in a 'municipal' sub-classical style. The monumental entrance block has attractive bronze-framed windows and a symbolic sculpture below the pediment. The left figure holding a scroll represents

Colonel G. C. Lowbridge's University of Wolverhampton Wulfruna Building.

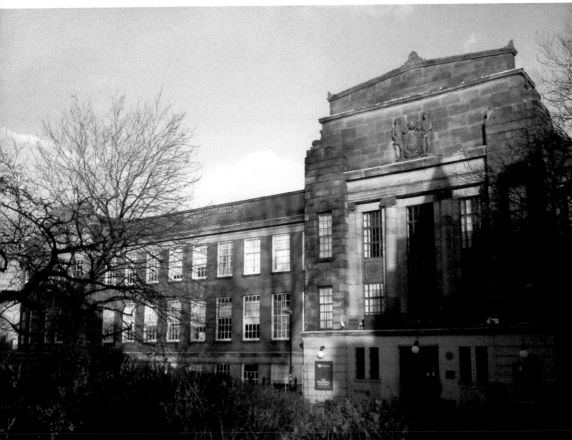

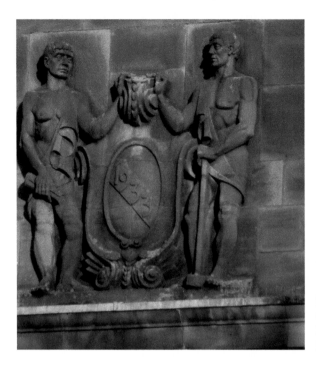

Industry and Learning
working together,
Lowbridge's Wulfruna
Building sculpture.

Learning and the right figure with its sledgehammer stands for Industry. Active engagement with local industry in its teaching continues to be an important theme in the university's work.

Inside the entrance block is a grand staircase lit by a top-floor half-dome. More recently, the reception and interiors have been upgraded by Wolverhampton architects Tweedale. The Chancellors Hall now has a separate entrance. Its accessible lift makes a distinctive architectural statement at the western end of the building.

The complex of teaching buildings expanded around this building up to the early 1950s and continued north up to the inner ring road by the 1970s. With grant of university status in 1992, a major millennium reconstruction of the northern buildings was planned. New blocks, the Rosalind Franklin building (q.v.), the Millennium City Building and the Alan Turing Building either reshaped earlier buildings or completely replaced them. Students now have their own entrance to the university through the Ambika Paul building (q.v.).

The university with more than 21,000 students has become a leading developer in the town. North of the ring road, Molineux Campus (opposite Wolves' football stadium) includes the 2015 Lord Swraj Paul building (architects Sheppard Robson) and the 2008 Housman Building (architects ADP). Beyond the city centre, the university is redeveloping the Springfield Brewery site (q.v.). The university's Science Park on Stafford Road, 1.5 miles north of the city centre, was initiated in 1993 and now houses more than a hundred enterprises, bringing potential work opportunities for the university's students and graduates.

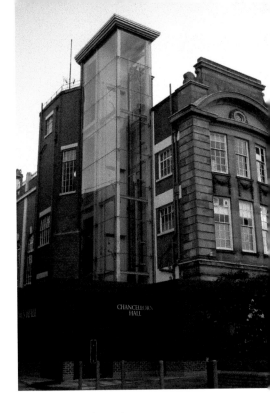

The Chancellors Hall's new lift shaft, a good modern addition to the Wulfruna Building.

36. Express and Star Buildings, Nos 51–53 Queen Street (1934)

Built in 1934, this is the headquarters building of Wolverhampton's evening newspaper, the *Express and Star*. The newspaper was already operating out of Nos 51–53 Queen Street by 1928 and had operated in Queen Street since 1884. Its buildings were originally Georgian-style houses. This rebuild created modern workspace inside including a showpiece library, a telephone room and a pneumatic tube messaging system.[26]

Outside, the centrepiece is the stone central bay with Ionic columns and a statue of Mercury, the messenger god. To its left, the four-storey 1934 block is also stone built. The architect, H. Marcus Brown, and the contractor, Wilson Lovatt, were both based in Wolverhampton. The stone supplier was Tarmac, locally based in Ettingshall. Tarmac used this patented 'Vinculum' reconstituted stone frontage to advertise its product.[27]

Its local listing is based on the building's 'landmark quality'. The *Express and Star* bought houses to the right of the entrance in the 1960s. The new office block was opened in 1965. Twentieth-century styles had moved on. The new building is a modern, glass-faced office but without the distinctive quality of the earlier buildings.

The plaque alongside the entrance celebrates the sculptor of Mercury, R. J. Emerson. He appears to have been a hugely charismatic teacher at Wolverhampton School of Art. The oldest of ten in a working family from Rothley near Leicester, his sculpting ability was recognised, and, in his early twenties, he began to win many sculpting prizes and local scholarships. He became the Second Master at Wolverhampton School of Art in 1910. In 1941, his friend Norvall Graham, the

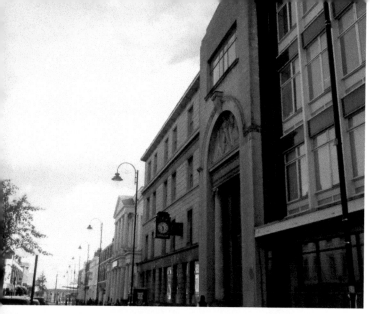

The *Express and Star*
buildings in Queen Street.

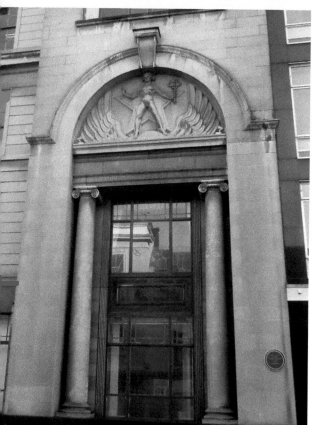

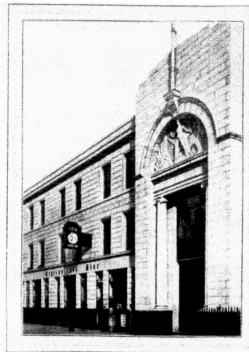

VINCULUM STONE

WAS SPECIFIED FOR THE EXPRESS AND STAR NEW OFFICE
ARCHITECT, H. MARCUS BROWN, L.R.I.B.

VINCULUM DEPT. OF TARMAC LT
ETTINGSHALL─────────────WOLVERHAMPTON

Above left: The arched central bay with sculptor R. J. Emerson's statue of Mercury.

Above right: Tarmac's advert for vinculum stone with the newly built offices. (Published with permission from Tarmac Ltd)

Express and Star editor, built studio space for him fronting Castle Street within the *Express and Star* buildings complex. His other work in and near Wolverhampton includes the Douglas Morris Harris memorial statue at St Peter's and the 1923 war memorial for Butler's Springfield Brewery, now at the Museum of the Black Country.

37. Civic Halls, North Street (1938)

The Civic Halls in North Street opened on 12 May 1938. Previous concerts in Wolverhampton were held in the Agricultural Hall, the Drill Hall or the Baths Assembly Hall with the public swimming pool boarded over. The accoustics in all were reported to be be atrocious. The council planned that the two new halls would be used for concerts, banquets, dances, meetings and receptions.

This building was the first project of young architects Lawrence Israel and Edward Duncan Lyons – twenty-two and twenty-five when they won the design competition for the new halls in 1934 ahead of 122 entries. Their inspiration, Edward Lyons would say many years later, came from Holland, Dudok's Hilversum Town Hall, and from Stockholm, Gunner Asplund's crematorium, Ragnar Ostberg's Town Hall and Ivar Tengbom's Concert Hall.[28]

Building work started in 1936 with local contractor Henry Willcock and Co. Construction was slow, with shortages of steel and bricklayers as public works across the country were under way to counteract the 1930s Depression, but was complete for opening in 1938.

Below left: Concept design of the Civic Hall refurbishment under way in 2021. (Published with permission from Space and Place)

Below right: The concept imagined from Mitre Fold from alongside the refurbished Civic Halls. (Published with permission from Space and Place)

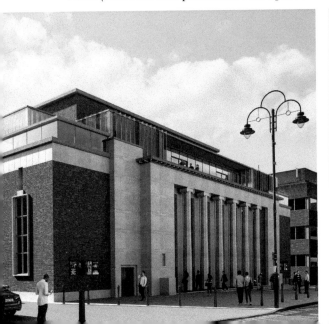
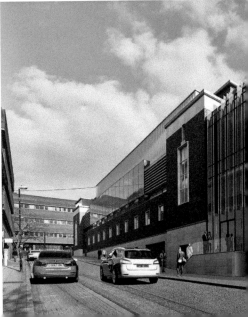

There are two halls, the larger Civic Hall and smaller Wulfrun Hall at the rear of the building. Each had its own entrances and conveniences. There was a shared central refreshment room and crush room. The Civic Hall could hold up to 1,700 people with space for an eighty-piece orchestra and a choir of 200. The Wulfrun Hall seated 700. Both had sprung dance floors.

The halls were renovated and extended in 2000–2001 by architects Penoyre and Prassad. The Civic Halls are in demand in the city, hosting events from band concerts to the Grand Slam of Darts. In 2021 further extensions, by designers Space and Place with builders Willmott Dixon, continue. The computer-generated images (CGI) show how the buildings could look when finished. The combined capacity of the halls will increase to 4,600 standing or 3,130 seated. There will be larger bars, extended stages, bigger seats and new air conditioning. The sprung dance floor will be refurbished.

38. Wetherspoons (former Co-op Building), Nos 53–55 Lichfield Street (1939 – late 1950s)

This building used to be the major Co-operative Society building in Wolverhampton. Entirely faced in white faience tiles, it was a refront of the Victorian/Edwardian shops and houses on this stretch of Litchfield Street. It is still possible to see how the earlier shops were reshaped first, in 1931, by architects Cleland and Hayward into Unity House with a unified shopping frontage at street level, and now into the street frontage as it appears today.[29]

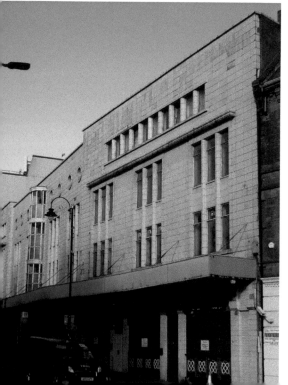

The former Co-operative department store main façade.

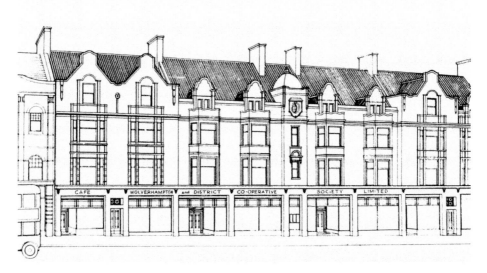

Above: Unity House, the 1931 Co-operative building frontage. (Published with permission from the collection of Ned Williams)

Right: A sunlit close-up of the former Co-op's tiled façade with window details.

From Unity House, the first two gables from the left have become the first panel of the new art deco frontage – farthest from the camera in the photo. The next pair of gables in Unity House, with the tower feature at their right, have become the next building panel, with bull's-eye windows at the top level and the tower feature rebuilt as a three-storey half-cylinder window. The final gables (spilling just beyond the right end of the elevation drawing) have been absorbed into the final building panel with its three groups of vertical windows. The art deco rebuild had to be staged while the shop still operated. Did this split of the design assist with the ten-year programme, closing off elements of the building one at a time for rebuild until all three segments were complete?

This Co-op department store closed completely in July 1987. Wetherspoons now occupies part of the ground floor as The Moon Under Water. Major development plans are being considered (2020) by the council for a Wetherspoons' expansion. The public house would be retained. The upper floors (empty since 1987) and a set-back roof extension would become a ninety-room hotel. The remaining ground-floor and basement areas would house a national Wetherspoons Heritage Centre. The frontage would be retained and fully repaired.

39. Mander Centre, Victoria Street and Dudley Street (1968)

In 1845, brothers Charles and Samuel Mander established varnish manufacturing in the centre of Wolverhampton at St John Street where they lived. By the 1960s, the Manders had been civic leaders in Wolverhampton for many years. They had become hereditary baronets. Members of the family were councillors and aldermen for the town council throughout the nineteenth century. Their factory extended into many buildings along St John Street. They saw the redevelopment opportunity and they acquired whatever property they could around it. They moved the works to Heath Town alongside another Mander factory at the north-eastern edge of Wolverhampton.

The Mander Centre, opened in March 1968, a radical shift with the Wulfrun Centre of the retail heart of Wolverhampton. The centre was an immediate commercial success. The trick was to build new shopping behind the existing shopping streets. The shops on Dudley Street and Victoria Streets could have new back entrances into the centre. The old streets kept their character. There was a direct main road entrance to the centre from Victoria Street and from Woolpack Alley at the end of King Street. Other entrances were from existing arcades and alleyways. The centre won a Civic Trust award, which commented that this centre 'has real magic, real urban quality and is made of real materials ... it is also full of people enjoying themselves'.

The architect, James A. Roberts, who also designed the Rotunda in Birmingham, specified the materials – plain concrete with added Portland stone, pine boarding, copper and bronze. The centre, originally open to the sky, was roofed in the mid-1980s.

Above: The Mander Centre's Victoria Street frontage block.

Below left: Farmer's Fold, one of the Mander Centre's discreet entrances from existing streets.

Below right: Inside the glass-roofed Mander Centre – a vibrant (and warm) space in midwinter. (Published with permission from the Mander Centre)

Mander Holdings sold on in the 1990s to Prudential Insurance. The centre was sold again to Benson Elliott Capital Management in 2014. Further improvements took place over the years. New main entrances were built to Dudley Street and Victoria Street. Debenham's department store – announced to be relet to House of Fraser in 2020 – was reshaped in a new atrium alongside other larger stores. The initial brutalist concrete has been softened into a modern glass and steel arcade.

40. Wulfrun Centre, Cleveland Street (1969)

Alongside the Mander Centre, the Wulfrun Centre was the council's own contribution to recreating the shopping centre of Wolverhampton in partnership with private developer Hammerson. The council did not have major difficulties with other users on the site. Most of Bell Street, a backland street of minor shops and commercial operators was demolished. All existing shop frontages on Garrick Street and Cleveland Street were cleared. The new outside elevations, concrete fins and huge panels, originally brick, on Cleveland Street and Garrick Street indicated an entirely new presence in the town with no concessions to its surroundings.

The centre has been upgraded. It was sold on and refurbished in the late 1990s with new glazed roofs, briefly overtaking the Mander Centre in the quality of the environment. It now seems fully up to date as a well-managed twenty-first-century developer's shopping centre.

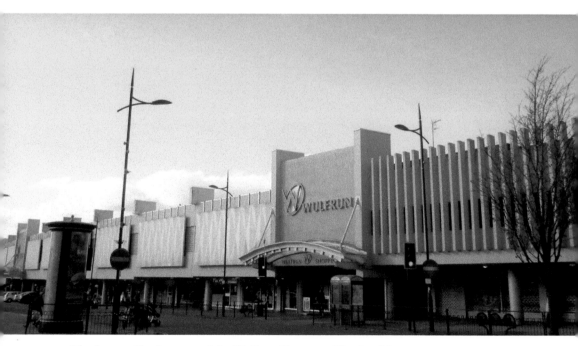

The fortress-like frontage of the Wulfrun Centre on Cleveland Street.

Above left: Inside the Wulfrun Centre, an attractive place to catch up with friends. (Image used with permission from LCP Properties)

Above right: The Wulfrun Centre's north entrance, a welcoming continuation of Dudley Street.

The Wulfrun Centre has kept its own distinct identity with anchor stores Primark and Poundland in 2020 and comparable smaller-scale retailers. The views from outside have been refreshed – the brick panels are now painted white. Below the central dome there is free-of-charge community performance or exhibition space that groups and individuals can book to use – upcoming events are published on a Facebook page. It forms a natural entrance at the south end of Dudley Street and has become a direct walking link between the town centre and the new open market (2002) on the opposite side of Cleveland Street.

41. Wolverhampton Civic Centre, St Peter's Square (1978)

The Civic Centre feels like a huge and rather grand ocean liner that has come gently to rest in the city centre. There are long, horizontal stretches of windows and Wolverhampton colour brickwork, a national Civic Centre style at the time. The architects Clifford Culpin and Partners had a long track record in designing civic buildings. In the 1930s, Clifford Culpin joined his father Ewart to form Culpin and Son. Only twenty-nine at the time, Clifford took design responsibillity for new town halls for both Poplar and Greenwich. By 1978, he was at the end of a distinguished career including a wide range of municipal buildings, council housing and more town halls.

Above: The Civic Centre
and its piazza, St Peter's
Square.

Left: The Civic Centre's
lower frontage, a Civic
Square with the Civic Halls
when complete.

Sadly, the town centre market and market hall had to be swept away to clear the space. In vogue at the time, the empty open piazza in front of the building now has no obvious use. The people who work here, however, help to keep the city centre alive. The building usefully also has nearly 400 car parking spaces. Major internal refurbishments from 2016 included improved customer facilities and reshaped workspaces, allowing the council to move its staff here and release peripheral offices.

42. Ambika Paul Building, Wulfruna Street (2003)

The core building here was the corporation architect-designed Robert Scott library of 1976. It was built on the site of St Peter's Primary School as the 1969 designated polytechnic expanded north of its Wulfruna Street core. Following grant of university status in 1992, the three-storey library was extended to four storeys with planning consent in 1996 obtained by architects Bond Bryan. Five years later, Bond Bryan were commissioned again to build an extended frontage (the building beneath the new aluminium roof, now the Harrison Library) and a completely redesigned new route through to the courtyard behind. Glass curtain walling is softened by horizontal brise-soleil external sun-shading grids, and the strongly emphasised flat roof.

The students' entrance is in a contrasting style with a reconstituted stone convex curved wall with a single vertical window through the two floors above the entrance. It provides a spacious way into the Ambika Paul Students Union, providing a communications and media suite, an IT workshop, a student lounge, shops, meeting and event spaces. The building was renamed in 2015 in memory of the daughter of university chancellor and supporter, Lord Swraj Paul.

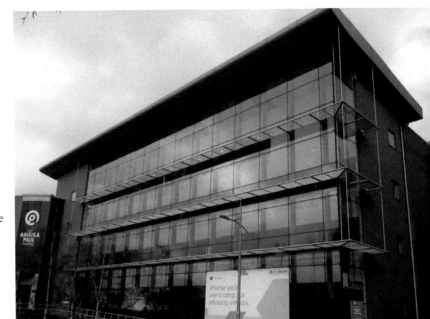

Bond Bryan's Harrison Library frontage alongside the Ambika Paul Building.

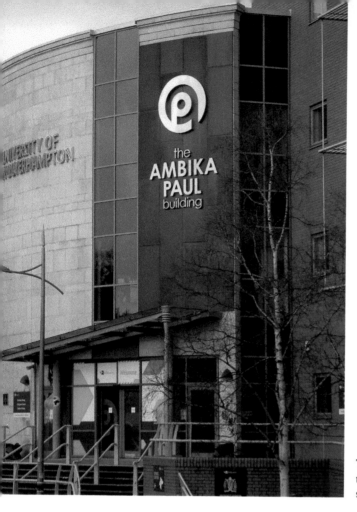

The Ambika Paul Building, the university's entrance for students.

43. Cross Street Flats, Cross Street South, Blakenhall (2008)

Cross Street Flats stand out as a housing scheme just south of Wolverhampton city centre. It's an impressive modern design with flat roofs, varied wall colours and attractive elevations with balconies and sun screens. The hard edge of building is softened with trees and low boundary hedges.

The scheme was specifically planned by the council as a sustainable contribution to the ongoing regeneration of Blakenhall in the first years of the twenty-first century. This site was originally a council-owned wasteland car park. Cross Street South at the time was dominated by the high-rise Blakenhall Gardens estate – 580 flats in two tower blocks and four massive nine-storey blocks. The estate occupied the whole area on the opposite side of Park Street South. Blakenhall was a poor area with high crime rates and dependent on local industries for its residents' employment. The government's thirty-nine-area New Deal for Communities (NDC) programme in 1998 brought a £50 million funding package. Blakenhall Gardens was progressively demolished between 2002 and 2011.

Above: Cross Street flats, a sophisticated modern building.

Below left: Plants soften one of the entrance bays along Cross Street.

Below right: Cross Street flats and local Blakenhall landmark, St Luke's Church.

Bromford Housing engaged architects Cole, Thompson and Anders and their linked green projects consultancy, Integer. The combined bid to the council was successful and this complex of thirty eco-friendly homes was the result. There are twenty-seven two-bedroom flats and three four-bedroom houses, all at subsidised rents for people who could not access housing on the open market. The homes are built with sustainable materials. External timber walls are insulated with material made from recycled newspapers. Roofs are grass covered, providing additional insulation. Collected rainwater can be used to water the allotments on site or wash cars. The scheme achieved EcoHomes Excellent, the highest rating achievable, when completed. Cross Street Flats was the 'Best Sustainable Larger Social Housing Project of the Year' at the 2008 Sustainable Housing awards.

The council provided its land for free and government funding agency the Housing Corporation contributed a £2.2 million grant. The scheme provides a new and entirely different housing environment for Blakenhall after the last tower block, Phoenix Rise, was demolished in 2011.

44. Heantun Point Student Housing, Culwell Street (2009)

These new student blocks are a landmark in Wolverhampton, visible from everywhere in the city. They are built on the site of the former railway lines, running north towards Shrewsbury from the GWR Low Level station. The railway closed in 1981, and the site was unused until this development. Planning permission in March 2008 was for 870 bedspaces in four blocks in total. This included these three blocks between Lock Street and Culwell Street and an additional fourth block, not developed, north of the pathway under the railway to the canal lock basin.

First designs had traditional load-bearing construction. But completion had to be in time for students to move in by September 2009, the start of the 2009/10 academic year. If flats were late, students would already have found their accommodation elsewhere and income for the year was at risk. Modular construction – individual flats built offsite, delivered and craned into place in their block – would save a full year in the construction programme.

Extensive redesign was needed. Structural continuity had to be maintained through first and ground floors containing non-standard uses, entrances, offices, refuse stores and common rooms. Architects O'Connell East reduced floor-to-floor height from 3.075 m to 2.800 m and added massive beams at first/second floors to transfer loads from the standard flats' layout above. Planning consent was granted in August 2008. Work was completed in twenty-seven weeks in good time ahead of the 2009 autumn term.

Councillors approving the scheme in 2008 unanimously welcomed what they believed would be a brilliant and iconic scheme for the city. Students have a new rapid route into town under the railway bridge. Their views of the flats vary,

Heantun Point flats, the complete student complex.

Modular construction
of Heantun Point in
progress. (Published
with permission from
OEA, O'Connell East
Architects)

as reported in reviews on various letting sites. Good management and friendly fellow students and staff are praised. Lapses from time to time in cleaning or staff helpfulness noted. The design of the buildings is barely mentioned – maybe a measure of how well the buildings fit their purpose.

45. St Luke's CofE Primary School, Park Street South, Blakenhall (2009)

St Luke's Primary School is an attractive building in keeping with the spirit of Blakenhall's regeneration. Blakenhall Gardens high-rise estate previously occupied this ground. Where six large blocks of flats once stood, surrounded by too much open grass, there is now space for the school and generous outdoor space, playgrounds and playing fields.

Architects Architype designed the school to maximise daylight, control solar gain and bring natural ventilation into all main spaces. The school is clad with UK-grown Douglas fir and the roof finished with cedar shingles. The long bands of windows with colour highlights look good from outside. The architects planned that the coloured glass windows, letting coloured light into the school, would keep up the association with St Luke's Church just down the road. Inside the school, natural timber provides a warm and friendly building finish.

The school was a replacement for existing St Luke's infant and junior school buildings on separate sites and no longer fit for purpose. Blakenhall New Deal

Below left: Architype Architects' St Luke's Primary School entrance – natural materials stand out. (Published with permission from St Luke's Primary School)

Below right: Bright colours used at St Luke's Primary School attract the eye. (Published with permission from St Luke's Primary School)

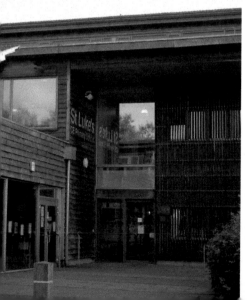

Natural materials provide shelter for the nursery class waiting point and entry. (Published with permission from St Luke's Primary School)

for Communities (ABCD) project had additional funding available alongside mainstream Education Department funding to create a 'community school'. The design includes spaces available to the other people living locally and allows public access outside hours without compromising teaching arrangements and classrooms.

The nursery drop-off point, entered from the east end public green, is in the sheltered space under a striking porch. There is a long run of canopy space outside the south-facing nursery, reception and early years classrooms. Teaching can spread into the open air when weather permits. School halls are visible to the left of the entrance porch from the green. There are also separate multi-activity spaces for the lower school and the upper school in the spaces in the centre of the school behind the classrooms.

46. Molineux Stadium, Waterloo Road (2010)

If you don't know it already, Wolverhampton Wanderers' history is displayed inside the subway under the ring road leading down to the stadium from the university. Molineux Stadium and the current stands match the club's progress. The oldest is the 1979 Steve Bull Stand. Wolves had finished in the top six in the top League division and won the 1980 League Cup. The club bought and demolished seventy-

one terraced houses in Molineux Street and spent £2.5 million on the new stand. Top football architects Atherden and Rutter were used. They had designed stands at Old Trafford and later built for Spurs at White Hart Lane.

Sadly, Wolves dropped quickly down the League until, in 1986, the council bought the ground to save the club. Land was sold to Gallaghers estates, which paid off outstanding debts and developed Asda. The club began to climb the league and won the Football League trophy in 1988. Recovery was taken forward by Sir Jack Hayward, who bought the club in 1990 and funded phased new stands – the Stan Cullis Stand in 1992 and the Billy Wright and the Jack Harris stands, which opened in August and December 1993. The architects were Alan Cotterell Partnership. A new phased redevelopment started in 2011 with a complete rebuild of the Stan Cullis Stand by AFL Architects, but the club was relegated at the end of 2012. New owners, Fosun, bought the club in 2016. By 2018 it was back in the Premier League, achieving seventh place in the two seasons up to 2020. New plans are on hold while the club prioritises small-scale improvements and building up the strength of the team.

Footballing heroes are celebrated in the stand names and statues around the ground. Stan Cullis was a legendary manager of the club from 1948 to 1964, winning the English League championship three times. Billy Wright captained the club in the same period, as well as captaining the England team. Steve Bull was a top goal scorer, with 306 goals for Wolverhampton from 1986 to 1999. Sir Jack Hayward, multimillionaire businessman, Bahamas property developer and sporting philanthropist, was the club's owner from 1990 to 2007.

A general view of Molineux Stadium as you approach on foot from the city centre.

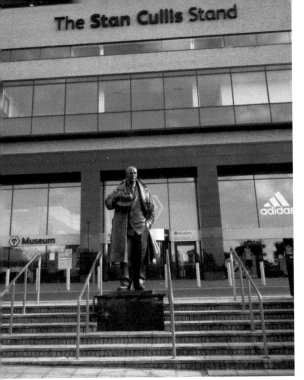
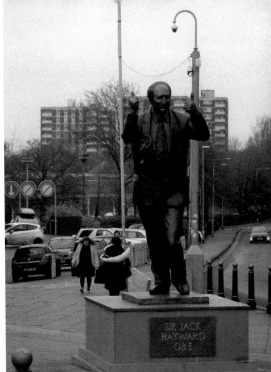

Above left: James Walter Butler's Stan Cullis statue in front of the stand that carries his name.

Above right: Sir Jack Hayward, also sculpted by Butler, greets everyone coming to the ground.

47. Wolverhampton Bus Station, Pipers Row (2011)

The bus station was the first stage of regeneration by the city council of the whole 'Interchange' area from here to the rail station. First phases included the Queens Building's restoration as part of the overall complex – new offices and shops along the route across Ring Road St David's towards the rail station.

The new bus station is a steel and glass replacement of the open bus stands on the same site. Waiting space is now enclosed inside three boulevards serving nineteen bus stands. Sides have wide-open views through plate glass. The tent roof structure is made of PTFE (polytetrafluoro-ethylene), developed by du Pont in the 1960s and used on structures since the early 1970s. Translucent sheets of glass fibres are embedded in Teflon. Unlike Perspex, it doesn't yellow with age. The outer surface is self-cleaning; rain should wash away any dirt that collects.

The station includes a large travel shop and state-of-the-art electronic displays of next bus times. The architects were Austin Smith Lloyd and contractor BAM. In its own way, the bus station is a landmark building, a civilised and attractive way to catch the bus.

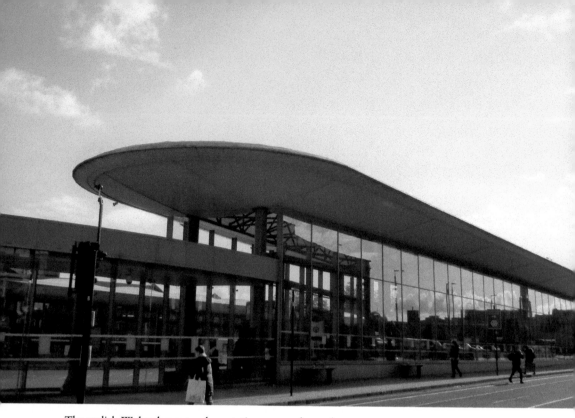

The stylish Wolverhampton bus station covered stands.

Inside one of the tented boulevards of the bus station. (Published with permission of the City of Wolverhampton Council)

48. Rosalind Franklin Building, Stafford Street (2014)

The Rosalind Franklin Building is a handsome new addition to Stafford Street. Its bronzed and glass façade fronts upgraded labs and research facilities for the university's chemistry courses. There is a new outreach laboratory that you can see on the ground floor from Stafford Street. Local schools can visit, and it provides international video and internet links that allow the university's courses to reach students worldwide.

Oxford-based BGS were the designers. The building is an elegant advertisement for a modern university. Bronze-anodised aluminium louvres give a strong vertical emphasis and provide sun diffusion for the full-height glass curtain walling. The distribution of louvres and windows lines up with the lab desk arrangements inside.

The new entrance to the university on Stafford Street leads through to the university central courtyard behind. The rebuild has retained the original art deco-style door portal and windows above from the previous chemistry labs, which were part-demolished for this new building. The building has been named after Rosalind Franklin (1920–58), one of the discoverers of the structure of DNA.

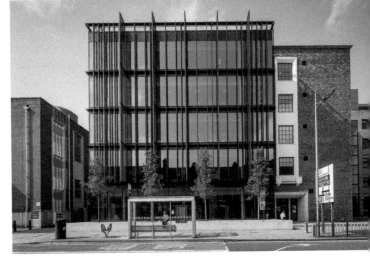

The Rosalind Franklin building, an attractive new frontage on Stafford Street. (Image by Quintin Lake Photography; published with permission of Neil Eaton, formerly of BGS Architects)

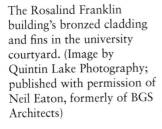

The Rosalind Franklin building's bronzed cladding and fins in the university courtyard. (Image by Quintin Lake Photography; published with permission of Neil Eaton, formerly of BGS Architects)

49. Springfield Campus, Grimstone Street (2017+)

The original brewery was built from 1873 onwards by William Butler and Co. Ltd and the architect was Robert C. Sinclair. The wells had run dry at their previous Priestfield Brewery, but Springfield benefited from plentiful fresh spring water. The business thrived until the 1950s, but following various takeovers it finally closed in 1991. It remained mostly vacant. Many buildings were destroyed and damaged by a major fire in 2004.

The site was bought by the university in 2015 as a hub for construction and built environment teaching and training activities. The first new activities were in the refurbished brewery stable buildings on either side of the entrance in Cambridge Street. Thomas Telford UTC (University Technical College) engaged Associated Architects to design stable renovations retaining the external red-brick Cambridge Street wall on the right of the gateway entrance. Their new three-storey block alongside has contrasting white cladding and dark blue brickwork details. The entrance atrium links old and new. UTC students came here in September 2017

On the other side of the gateway, the stable blocks in the photo were reconstructed for the Black Country ECMS (Elite Centre for Manufacturing Skills), which opened in August 2017. The centre is a partnership specialising in metalworking skills with links to metal forming and cast metals industry bodies. It organises apprenticeships and short courses. Wolverhampton-based Tweedale were the architects for the refurbishments.

Below left: Old and new at the entrance to Wolverhampton University Technical College, Springfield Campus. (Published with permission of the University of Wolverhampton)

Below right: Brewery stables revived for the Black Country Elite Centre for Manufacturing Skills. (Published with permission of the University of Wolverhampton)

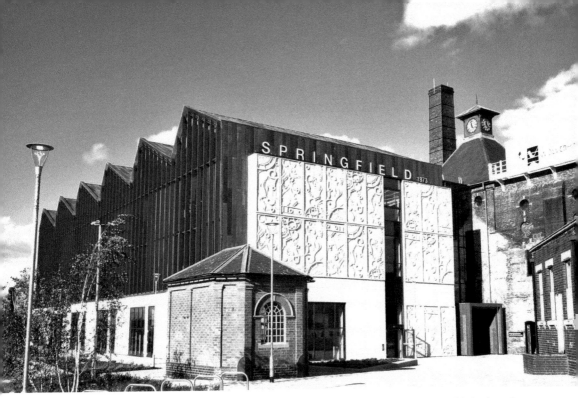

Springfield Campus School of Architecture and the Built Environment. (Published with permission of the University of Wolverhampton)

SOABE, the university's School of Architecture and the Built Environment, has taken on the main surviving blocks of brewery buildings at the Grimstone Street end of the site. Associated Architects has revived the attractive clock/cupola and created a feature light box that replicates the brewery water supply tank that was once here. Their main block has laboratories and classrooms on the ground and first floors. Top-floor studios have distinctive saw-tooth roofs that provide north lights and south-facing slopes for photovoltaic cells. Bronze cladding with vertical bronze sun screens and the white concrete feature panels make an attractive counterpoint to the surviving brick buildings.

5c. Wolverhampton Station (2021)

Wolverhampton station is being redeveloped as part of the larger-scale Wolverhampton Interchange project. This inlcudes the new bus station (q.v.), a recreated pedestrian route across the ring road from the Queens Building (q.v.) and new shops and offices on either side of it. The old station had been built as part of the electrification programme of lines between London and the North West carried out in 1964–67. It was less than generous in its planning and had become completely overcrowded.

The first new phases were open by 2020. The entrance and concourse leads to a hugely enlarged suite of ticket barrier entries to the first platform – Platform 1. A replacement spacious footbridge to other platforms had already been completed towards the north along the platform. It relieved the older cramped footbridge to the right of the platform entry and gave access to a completely new eastern platform, Platform 4. To the left of the entrance, there is a single office floor façade clad with colour-coated aluminium panels and with coloured aluminium fins. A feature extra storey step-up of the frontage canopy highlights the station entrance. The orange and black colouring is a Wolverhampton signature – the home colours of football team Wolverhampton Wanderers.

The old station was demolished for the second phase. It will be replaced by a continuing sweep of new buildings to the right complementing the Phase 1 buildings on the left. New shops at ground level face the Metro tram stopping point. The reconstruction is a partnership between the city council and Ion Development with architects Austin-Smith Lord and contractor Galliford Try.

Above: The new portal entry to Wolverhampton station. (Image taken by Paul Arthur Photography; published with permission of Galliford Try)

Left: Black cladding with orange fins for the new offices at Wolverhampton station. (Image taken by Paul Arthur Photography; published with permission of Galliford Try)

Notes

1. Bridges (2008), p. 126
2. Upton (1980), pp. 20–21
3. Roper (1957), p. 33
4. City of Wolverhampton Council, *Wolverhampton City Centre, Conservation Area Apppraisal and Management Proposals* (Wolverhampton, 2007)
5. Noszlopy and Waterhouse (2005), p. 247
6. Hickman, Peter, 'St John's in the Square: The New Church' (historywebsite. co.uk)
7. Roper (1957), p. 39
8. Hudson, Ashleigh (ed.), *Queen Street Wolverhampton Essays*, p. 43 et seq.
9. Historic England, 'Roman Catholic Church of St Peter and St Paul' (List Entry Number 1201844. Internet entry: historicengland.org.uk/listing/the-list/list-entry/1201844, as amended 27-Jun-2016)
10. Op. cit. p. 62
11. Op. cit. p. 44
12. *The Builder,* Volume 4 (31 January 1846, p58)
13. Bridges (2008), p. 135
14. manchestervictorianarchitects.org.uk/buildings/town-hall-wolverhampton
15. Historic England, 'West Park' (List Entry Number 1001206. Internet entry: historicengland.org.uk/listing/the-list/list-entry/1001206 as amended 20 August 2013)
16. Jones, Joseph (1897), p. 138
17. *The Builder,* Volume 67 (14 July 1894), p. 29
18. Mackintosh and Sell (1982), p. 192
19. Pearson (2016), p. 53
20. Harwood, Elaine, *Pevsner Architectural Guides: Nottingham* (New Haven and London: Yale University Press, 2008) p. 20
21. Pevsner (2002), p. 317
22. Fellows (1995), pp. 128–134
23. Historic England, 'Ohel and Walls to Jews Burial Ground' (List Entry Number 1392726. Internet entry: historicengland.org.uk/listing/the-list/list-entry/1392726 as first listed 27 August 2008)
24. Kelly's Directory of Staffordshire (London, 1912), p. 589

25. See details of Subeam Car history on *Wolverhampton History and Heritage Website* at historywebsite.co.uk/Museum/Transport/Cars/Sunbeam.htm

26. *Wolverhampton History and Heritage Website* (at historywebsite.co.uk/listed/localist/queenstExStar.htm) refers to Rhodes, Peter, *The Loaded Hour: a History of the Express and Star* (SPA Ltd, 1992), pp. 88–89, for details of the building history

27. Copy poster and further details from *Tarmac – The First 80 Years* (*Wolverhampton History Website*, historywebsite.co.uk/Museum/Tarmac/Group.htm)

28. Wolves Civic website, *History, Plans and Drawings* (yourwolvescivic.co.uk/history/plans-and-drawings.html)

29. Williams (1993), p. 69

Bibliography

Bridges, Tim, *Churches of the Black Country* (Little Logaston: Logaston Press, 2008)

Fellows, Richard, *Edwardian Architecture, Style and Technology* (London: Lund Hamphries Publishers Limited, 1995)

Jones, Joseph: *Historical Sketch of the Art and Literary Institutions of Wolverhampton* (London: Alexander and Shepheard, 1897)

Mackintosh, Iain and Michael Sell (eds), *Curtains!!! Or a New Life for Old Theatres* (London: John Offord (Publications) Limited, 1982)

Mason, Frank, *The Book of Wolverhampton* (Buckingham: Barracuda Books Ltd, 1979)

Noszlopy, George T. and Fiona Waterhouse, *Public Sculpture of Staffordshire and the Black Country* (Liverpool: Liverpool University Press, 2005)

Pearson, Lynn, *Victorian and Edwardian British Industrial Architecture* (Ramsbury: The Crowood Press, 2016)

Pevsner, Nikolaus, *The Buildings of England, Staffordshire* (New Haven and London: Yale University Press, 2002)

Roper, John S., *Historic Buildings of Wolverhampton* (Wolverhampton: 1957)

Thorold, Henry, *Staffordshire, A Shell Guide* (London: Faber and Faber, 1978)

Upton, Chris, *A History of Wolverhampton* (Chichester: Phillimore and Co. Ltd, 1998)

Williams, Ned, *The Co-op in Birmingham and the Black Country* (Wolverhampton: Uralia Press, 1993)

Acknowledgements

It has been a pleasure to have help from so many people from Wolverhampton and beyond in assembling this book. Architects and contractors have been generous with their images: Gary East and Jenny Hayes at OEA Architects; Neil Eaton, formerly at BGS Architects; Justin O'Brien and Weronika Banaszewska at Space&Place; Ben Kunicki at Galliford Try; and Richard Cronin at Austin Smith Lord. Wolverhampton churches and places of worship have helped me with access to their buildings and people have taken time to show me around. Many thanks to David Wright and Revd Amanda Pike at St Peter's and St John's, Mgr Mark Crisp for Giffard House and St Peter and St Paul's, Fr Bielak and Andy Butwilowski at St Mary and St John's, Surjit Singh Uppal at Guru Teg Bahadur Gurdwara and Paul Hooper and Alan at the Church of St Silas COE (Continuing).

At Blakenhall, I appreciated the help of Mrs Grennan at St Luke's Church of England Primary School and of Dave Usher of St Luke's Church Antiques. It was great to speak to Laura Wallace covering Blakenhall for Neighbourhood Police Safety and to Mark Cooper, who updated me on other Blakenhall buildings.

Other researchers have helped me with information and permissions to use their images. My thanks to Neil Fox at the Royal Hospital and Ned Williams for his work on the Co-op. Nicholas Philpot, an expert on Montague Burton's buildings, corrected my misconception of the elephant capitals on the former Burtons frontage incorporated into Beatties' (now also former) frontage. I have a particular debt of gratitude to everyone who has worked on the Wolverhampton History Website, a wonderful resource for anyone visiting the city. My thanks expecially to Bev Parker for his numerous website articles and for making it possible to find Neil Fox at New Cross Hospital.

Despite the pandemic in 2020, commercial organisations helped where they could. Barclays Bank Archives was virtually closed initially, but six months later James Darby and Rosie Fogarty were able to send me key information about the Queen Square Barclays and HSBC buidlings. Peter Judge at Lloyds Group Archives provided unique information about its Queen Square branch. Laura Taylor at the Mander Centre provided permission to photograph and contributed her ideas about best images. Anneka Lowe of LCP Properties provided stock images for the Wulfrun Centre. Will Britten at Tarmac chased for permission to use their Vinculum Stone advertisement. Nathan Birne at the Grand Theatre moved commitments to show me round.

Joe Perry at City of Wolverhampton and Terry Gibson and Vickie Warren at the University of Wolverhampton have helped with the permissions I needed for photographs within council and univeristy buidlings and grounds. I have also appreciated help from all the staff at the archives, who were able to work only periodically during the past year with opening restricted by the pandemic.

Finally a thank you to my wife who has tolerated my year-long obsession with this book and still been able to come up with helpful suggestions and ideas to improve it. In the end the book has been hugely improved by everyone's contributions. I should like to put on record my thanks to Amberley Publishing and my comissioning editor Nick Grant for accepting my proposal to write this book. A big thank you to all. It's not perfect and the faults that remain are entirely the author's responsibility.

About the Author

Steve Bower's introduction to Wolverhampton came in the late 1960s and early 1970s, living in Birmingham and exploring the Black Country. Following qualifications in engineering and town planning, he has worked for many years as a developer of social and affordable housing. His passion for buildings and how they create exciting towns continues. Among photographic expeditions to many English towns from 2010 onwards, he rediscovered Wolverhampton and realised that there was little published about the city's architectural heritage. This book is the result.